PICASSO'S VOLLARD SUITE

Picasso's Vollard Suite

INTRODUCTION BY HANS BOLLIGER

THAMES AND HUDSON

Translation by Norbert Guterman

Published in the USA in 1985
by Thames and Hudson Inc.,
500 Fifth Avenue, New York, New York 10110

Library of Congress Catalog Card Number 85-50441

Filmset and printed in Great Britain by
BAS Printers Limited, Over Wallop, Hampshire

The publication of the hundred etchings created by Picasso between 1930 and 1937 was one of Ambroise Vollard's most impressive undertakings. The significance of the *Suite Vollard*, as it is generally called today, can be fully assessed only in the light of this man's personality and achievements.

Ambroise Vollard, one of the greatest art dealers and publishers of our time, has remained relatively unknown. The reason for this may be that only a part of his publications (altogether, some thirty-five books and portfolios) appeared in his lifetime; moreover these works, printed in relatively expensive limited editions, were acquired by only a few collectors, or by libraries and museums, where they were not readily accessible. At the time of their appearance, the boldness of their presentation caused these publications to be turned down by the collectors. Today we place them among the great cultural achievements of the century. History has likewise vindicated Vollard's sure artistic instinct and his championship of the once controversial painters Cézanne, Renoir, Gauguin, Van Gogh, Rousseau, Rouault, and Picasso, to name only a few.[1]

Ambroise Vollard, the son of a notary, was born on Reunion Island in 1867. He was an extraordinarily poor pupil, and obtained his baccalaureate diploma by 'a miracle'. In the late 1880s he went to Montpellier to study law. Around 1890 he moved to Paris, where he obtained the degree of *licencié en droit* and passed his preliminary examination for the doctorate of law. It was then that the instinct that was to shape his career awakened in him: he began to scour the Quais and the small shops of the Quartier Latin for drawings and engravings which at that time could be bought for a song. His expeditions brought in so much booty that he soon gave up his studies. Those were happy days for a collector. As Vollard tells us in his memoirs, a major painting by Manet could be had for less than 1,000 francs;

important Renoirs were offered for 400 francs and scarcely found buyers. Van Gogh died in 1890; shortly before his death the only picture of his sold in his lifetime had brought 400 francs at an exhibition in Brussels. Vollard bought Cézannes from Père Tanguy, paying 100 francs apiece for large canvases, and forty for small ones. He sensed that this was his great opportunity. He applied for a position at the Georges Petit gallery to prepare himself for the career of an art dealer. Georges Petit asked only one question: 'How many languages do you know?' Vollard knew only French, and was rejected. Then he was taken on at the newly founded gallery *L'Union artistique*, where he sold mediocre paintings.

Toward 1893 he opened a small gallery of his own at 39 Rue Laffitte. Two years later he moved to new quarters at 6 Rue Laffitte, where he remained until 1914. Those were the years in which Vollard's gallery was the centre of the Paris avant-garde, the meeting place of artists and collectors. He bought paintings from all the great artists of his time, and his publishing activities began to take shape. Degas, Forain, Renoir, the Nabis—Bonnard, Roussel, Vuillard, and Denis—and Cézanne, whose first exhibition including over 100 paintings he organized, became his friends. He bought their paintings and drawings. He paid them little, but he was a steady buyer.

After 1890 graphic art advanced by leaps and bounds. Gauguin, Munch, and Vallotton developed new possibilities of expression in the woodcut. Lithography received new impetus from the poster, which Chéret, Toulouse-Lautrec, and Bonnard raised to the rank of art. It was at this time that the visual appeal of the poster, used to advertise theatres, cabarets, etc., came to be generally recognized. The centenary of the invention of lithography was celebrated in 1897. Bonnard, Toulouse-Lautrec, Vuillard, Munch, and Redon had their lithographs printed by Auguste Clot, the foremost printer of the time. The young artists experimented with all the possibilities of colour lithography. Vollard, who was alert to every artistic movement, quickly perceived the opportunities created by this development. However, he was not the first publisher of works of graphic art. *Estampes originales* (1893), *L'Epreuve* (1895), the *Album de la Revue blanche* (1895), and other similar publications preceded his. But Vollard had an eye for new ideas and superior talents.

With the opening of the gallery at 6 Rue Laffitte, the publication of prints became one of his chief interests. 'But I commissioned painters to do them.

"Painter engraver" is a term that has been much abused, applied to professional engravers who were anything but painters. My idea was to order engravings from artists who were not professional engravers. What might have been looked upon as a hazardous venture, turned out to be a great artistic success.'[2]

The first publication bearing Vollard's imprint is dated 1895. It is a portfolio entitled *Quelques Aspects de la Vie de Paris*. These twelve magnificent colour lithographs by Pierre Bonnard are full of the flavour and atmosphere of Paris. In 1896 Vollard published the first, and in 1897 the second *Album des Peintres-Graveurs* with sheets by Bonnard, Carrière, Cross, Munch, Pissarro, Redon, Renoir, Rodin, Roussel, Sisley, Toulouse-Lautrec, Vallotton, Vuillard, and others. The two portfolios were issued in editions of 100 copies each; the first sold for 100, the second for 150 francs. Commercially these publications were anything but successful: twenty years later they had not been sold out. Vollard was not deterred by these failures. His profits as an art dealer were now so great that he could afford his hobby. Further portfolios, prints, and series of illustrations now appeared in rapid succession.

The year 1900 was crucial for Vollard: he published his first illustrated book. In his *Souvenirs d'un marchand de tableaux*, he writes: 'One day in the course of my walks on the Quais I began to glance through some volumes on a bookseller's stand. On the title page of a large in-octavo I read, "Ambroise Firmin-Didot, publisher". "Ambroise Vollard, publisher", I thought, would not look bad either. Little by little this idea took hold of me. I could not see a sheet of fine paper without saying to myself, "How lovely this would look covered with print!" And if I hesitated, it was only about whether to select a prose writer or a poet.'[3]

Even his first book, *Parallèlement* by Paul Verlaine, with illustrations by Pierre Bonnard, is a masterpiece. Today it is justly regarded as the first modern illustrated book of the century, and as one of the most beautifully illustrated books of all time. In *Parallèlement* Bonnard achieved a rare harmony of text, illustration, and typography. Majestically the illustration fills out the whole page, including the margins. It covers the text like a delicate mesh. Typography and illustration merge into one; under the spell of the illustration, the reader follows the text beneath it.

The next two books, *L'Almanach illustré du Père Ubu* by Jarry and *Daphnis et Chloé* by Longus, are also illustrated by Bonnard. These first books with their

lithographic illustrations were rejected by nearly all the collectors, because at that time bibliophiles recognized only woodcuts as proper illustrations. But Vollard's new passion was stronger than the objections of the critics and the boycott of the collectors. Before 1939 he had published more than twenty magnificent volumes. Ancient classics, works by French authors of the nineteenth century, and modern ones were illustrated by leading artists.[4]

For his books Vollard spared neither time nor money. He obtained the services of the greatest specialists, who helped the artists to master technical difficulties. For the lithographs he engaged Auguste Clot, and for the etchings and aquatints Louis Fort, and later Roger Lacourière. The text illustrations and vignettes were for the most part woodcuts made after the artist's drawings by such men as Aubert or the Beltrand brothers. The incomparable technical mastery of these craftsmen did much to enhance the artist's statement. Finally, the texts were printed by France's best printing establishment, the Imprimerie Nationale.

Vollard worked and experimented indefatigably, choosing the text, the type, and the appropriate illustrative technique. He spared neither the strength nor the patience of the artists. For years on end Rouault was kept busy on his works, Chagall on his illustrations for Gogol's *Ames mortes*, La Fontaine's *Fables*, and the Bible.

Vollard sold paintings to a relatively restricted clientele. After the first difficult years the most important museums and the greatest collectors were among his customers—Morozov, Barnes, Camondo, Hahnloser, and Gertrude and Leo Stein. He was an important art dealer, but it is as a publisher of prints and books, and as a writer,[5] that he will be known in the history of art.

When he died in 1939 he left behind twenty-four-odd projects for books, some of them well advanced. Among these are Braque's illustrations for Hesiod's *Theogony*; illustrations by Rouault, Redon, Derain, Dufy, Roussel, Laprade, and Vuillard; and Picasso's aquatints for Buffon's *Histoire naturelle* and illustrations for André Suarès' *Hélène chez Archimède*. The two last-named works were published during and after the war—*Histoire naturelle* in 1942, under the imprint of Fabiani, and *Hélène chez Archimède* in 1955, under the imprint of the Nouveau Cercle Parisien du Livre. Chagall's illustrations for *Ames mortes* were published only in 1948 thanks to the efforts of Tériade; La Fontaine's *Fables* were published in 1952 by Maeght.

The editions of Picasso are doubtless among Vollard's chief achievements as a publisher. They are: the fifteen etchings of the *Saltimbanques* series of 1904 and 1905, published in 1913; the illustrations for Balzac's *Chef-d'œuvre inconnu*; the thirty-one etchings for Buffon's *Histoire naturelle*; the twenty-one woodcuts done after drawings by Picasso for the *Hélène chez Archimède* of André Suarès; and finally the 100 sheets of the *Suite Vollard*, created between 1930 and 1937.

Picasso met Vollard during his second visit to Paris in 1901. He was introduced to the art dealer by Pedro Manach, his first patron. In July Vollard organized an exhibition of the twenty-year-old artist's works along with those of his friend Iturrino. The exhibition was not a success, but earned Picasso a very favourable review by Félicien Fagus (*Revue Blanche*, 1901, No. 25, pp. 464–65). The following year Vollard exhibited the first works of Picasso's blue period.

Until about 1910 Vollard regularly bought his works. He showed a particular predilection for the delicate paintings of the blue and pink periods. Fernande Olivier tells us[6] how one day (*c.* 1905) Vollard acquired thirty paintings of various sizes, paying 2,000 francs for them—at that time a considerable sum of money for Picasso.

Vollard had his misgivings about Picasso's great revolutionary advances, the Negro period, and above all, the Cubist period. He was the great buyer of Cézannes, Renoirs, Degas, Rouaults, Bonnards, and Vuillards; but now developments passed him by. Picasso's portrait of Vollard done in 1910 strikes us as the artist's farewell to the art dealer. Picasso was drawn to a new personality— Daniel Henry Kahnweiler, who in 1907 had opened a gallery at 28 Rue Vignon. This was the meeting place of the avant-garde painters—Braque, Léger, Derain, Vlaminck; and Picasso, too, began to come in almost every day. From December 1912 to 1914 Kahnweiler was Picasso's exclusive dealer. Under the terms of the contract, however, Picasso was left free to sell those of his earlier works that were still in his possession.[7]

Nevertheless his connection with Vollard does not seem to have been severed, for as late as 1913 Vollard published the fifteen etchings of the *Saltimbanques* series from the blue and pink periods. By 1923 Vollard had bought five more etchings (G. 30, 39, 60, 68, and 106),[8] and about 1927 another fifteen (G. 117–18, 121, 123–34). Twelve of these etchings were later used as illustrations of Balzac's *Chef-d'œuvre inconnu*. Among these, two treat the motif of the sculptor, which here makes

its first appearance, and which Picasso six years later treated so intensively in the *Suite Vollard*. The *Chef-d'œuvre inconnu* was published in 1931. The same year Albert Skira published *Les Métamorphoses d'Ovide* with thirty illustrations by Picasso.

The great success of these two books stimulated Picasso's interest in etching. Vollard saw a new opportunity for his publishing activity, and immediately ordered 100 plates from Picasso—the future *Suite Vollard*. In 1937 he was in possession of these 100 plates.

Roger Lacourière was commissioned to print an edition which consisted of three signed copies on parchment, 250 copies on Montval paper ($13\frac{3}{8} \times 17\frac{5}{16}''$, watermarked 'Vollard' or 'Picasso'), and fifty copies on Montval paper watermarked 'Papeterie Montgolfier à Montval' ($15\frac{1}{8} \times 19\frac{11}{16}''$).

Ambroise Vollard died in an auto accident on July 22, 1939. During the war the greater part of the edition of the *Suite Vollard* was bought by the dealer in prints Georges Petiet. The first series, printed on paper and signed by Picasso, was offered for sale in 1950.

According to the current classification the *Suite* includes twenty-seven separate sheets dealing with various themes, and seventy-three sheets on five themes— Battle of Love (5 sheets), The Sculptor's Studio (46 sheets), Rembrandt (4 sheets), The Minotaur and The Blind Minotaur (15 sheets); and finally the three portraits of Ambroise Vollard. At first sight the variety of themes treated might suggest incoherence. However, when the sheets are exhibited all together, one is struck by their unity of underlying implication and tone.

The twenty-seven detached sheets were done over seven years, from 1930 to 1936. The forty-six sheets dealing with the Sculptor's Studio represent a unique creative eruption—forty of them were executed between March and May 5, 1933, and six between January and March of 1934. The eleven Minotaur sheets were completed between May 17 and June 18, 1933. The five sheets on the Battle of Love date from 1933. The Rembrandt sheets were done from January 7 to January 31, and the magnificent four sheets of the Blind Minotaur between September 22 and October 23, 1934. The series, which now comprised ninety-seven sheets, was concluded in the course of 1937 with three magnificent portraits

of Vollard. To sum up, three sheets date from 1930, seven from 1931, one from 1932, sixty-two from 1933, twenty-one from 1934, two from 1935, one from 1936, and finally the three last sheets from 1937.

The majority of the sheets reflect the neoclassical component of Picasso's work, which made its first appearance in his engraving in the 'Pierrot' of 1918 (G. 55). A year earlier, in Rome[9] and in the course of trips to Florence, Naples, and Pompeii, Picasso had come into contact with ancient art. In the early 1920s these impressions were reflected in a series of splendid etchings and lithographs including portraits, beach scenes, and groups of women (G. 57, 63–65, 103–10, 223, 228–31, 233–38). The neoclassical manner developed in these works, for the most part line drawings, was to run like a red thread through all of Picasso's successive styles. This neoclassical vein is most clearly discernible in the illustrations for the *Chef-d'œuvre inconnu* and the *Métamorphoses d'Ovide*, the sheets of the *Lysistrata*, and the greater part of the *Suite Vollard*.

In 1932 Picasso bought the château Boisgeloup near Gisors, where he devoted himself primarily to sculpture in the years that followed. The theme of the Sculptor in his Studio is treated in forty-six sheets, which Picasso dated beginning March 20, and which can be followed like entries in a diary. On some days he did as many as four plates. We can see how the subject fascinated him. The theme is developed with epic breadth. All of the artist's moods are marvellously suggested. This is an infinitely quiet, archaic world, far removed from all bucolic gaiety. The sculptor's face always shows the same intense concentration, and the model too breathes gravity and restraint. The model is shown in all sorts of positions, draped in many different ways; she becomes wholly a part of the artist's work, of the atmosphere in which he lives. But sometimes it is as though Picasso could no longer bear this idyl of classical tranquillity, for both in theme and in composition the Battle of Love, created at the same time, represents the sharpest contrast to the restraint of the *Studio* series. In these five sheets the severe neoclassical line drawing yields to an unprecedented expressive dynamism and an ever increasing richness of orchestration. In one of the sheets (No. 30) Picasso constructs the intertwined bodies with purely linear means, while in those preceding and following (Nos. 28, 29, 31, 32) the composition becomes gradually more plastic; the volume is at first created by a differentiated graphic interpretation, and in the end by the methods of painting. And whereas in the other cycles the theme is

presented in continually new variations, these sheets almost seem to be different aspects of the same composition.

In 1934 Albert Skira and the publisher Tériade founded the magazine *Minotaure*. Picasso designed the cover of the first issue. In the *Suite Vollard* he further developed the subject of the Minotaur, freely interpreting the ancient myth and creating an entirely new mythical world. For him the Minotaur is the ideal union of man and animal. He represents him as a tender seducer (No. 84), he shows him carousing at a party in the sculptor's studio (Nos. 85, 92), as a lecherous creature rushing at a girl (No. 87), or bending in awkward tenderness over a sleeping woman (No. 93). The Minotaur is defeated by a youth in the arena (No. 89), and in the next sheet he is seen expiring from a mortal wound (No. 90). The first eleven plates were executed between May 17 and June 18, 1933. In September of the following year Picasso's imagination was again kindled by the subject of the Minotaur: in four magnificent engravings he represents the tragic figure of the blinded creature, deprived of all his strength by an innocent little girl who in one picture is seen holding a bouquet (No. 94) and in another a dove, the symbol of purity (No. 95). Silent spectators, benumbed by compassion, follow the scene. Most moving is the aquatint of the girl with the fluttering dove, leading the blinded Minotaur through the night (No. 97)—a work magnificent for its mood, its composition, its symbolic force, and its technical perfection. The fascination of this work is enhanced by the mysterious lights that seem to emanate from the bodies themselves.

In a conversation with Daniel Henry Kahnweiler, Picasso related how the four Rembrandt sheets were conceived: 'Just imagine, I've done a portrait of Rembrandt. It's all on account of that varnish that cracks. It happened to one of my plates. I said to myself, "It's spoiled, I'll just do any old thing on it." I began to scrawl. What came out was Rembrandt. I began to like it, and I kept on. I even did another one, with his turban, his furs, and his eye—his elephant's eye, you know. Now I'm going on with the plate to see if I can get blacks like his—you don't get them at the first try.'[10] Here, as in the two sheets added later, Picasso seems to master the richness of Rembrandt's etching technique—from the delicate silver pencil stroke of the dry points to the velvety deep black of the etchings. At the same time he seems to be trying to make his peace with the disquieting fascination of Rembrandt.

The current classification of the engravings contained in the *Suite Vollard* appears somewhat arbitrary. Among the twenty-seven sheets that are not included in any of the cycles, there are a few that could easily be connected with one of the main themes. Obviously the tippler at the left of sheet 12, with its jocose line, is closely related to the Rembrandt sheets. The heads on sheet 25 are probably sketches for the bearded fishermen in the Blinded Minotaur sequence. And in their subject matter, sheets 6 and 7 are closely related to the Sculptor cycle.

Another group of the separate sheets reveals themes that run through Picasso's engraving like leitmotivs—the circus scenes (sheet 17), the bullfight (sheets 15, 16, 22), women dressing (sheets 2, 3), the rape (sheet 9). Picasso had been treating these subjects for decades, ever since his youth; the rape occurs as early as 1905, in the pink period (G. 16). His approach in this early work is realistic; in the etching *Homme et Femme* dating from 1927 (G. 118) he shifts to a purely linear interpretation of the theme. In sheet 9 of the *Suite Vollard* the expression is greatly enhanced: over the entire page there extends a graphic field of energy, in which the contours of the bodies seem to delimit magnetic zones.

In every field of art, in engraving as well as in painting and sculpture, Picasso repeatedly surprises us by his sovereign creative freedom. Often he succeeds in combining his familiar themes and elements into completely new creations; and he is tireless in experimenting with new techniques. In 1936 the printer Roger Lacourière showed him the sugar process or 'lift ground' method of aquatint.[11] Sheets 24, 26, and 27 of the *Suite Vollard*, which are done in this technique, are true masterpieces; here the potentialities of the new process are brilliantly exploited to create a mythical-romantic mood. The nocturnal demonic world of the three masked figures impresses us as a contrapuntal contrast to the classically balanced daytime world of the Sculptor sequence. The symbolic masked figures form a parallel to the sculpture bearing the features of Harpies.

The other two sheets represent the sleeping women. On sheet 26 she is regarded by a boy, who on sheet 97 reacts with the same grave surprise, indeed with the same gesture, to the terrifying appearance of the blind Minotaur. The candle, a symbol of light, and its artistic treatment reflect a peaceful nocturnal situation, which in sheet 27 is disturbed by the restrained lewdness of the satyr, and still more by the glaring illumination suggestive of a searchlight. The resulting

division of the picture into two large triangular planes anticipates the brilliantly conceived composition of *Guernica* with its overlapping triangles.

The three portraits of Vollard were added to the *Suite Vollard* after the other ninety-seven plates had been executed. Picasso first resorts to the soft-ground technique whose effect is predominantly that of a painting (sheet 98). In the last sheet he re-creates the complex personality of Vollard in a grandiosely simplified dry point, divested of any quality of painting. The old man's creative passion, his solitude, his sudden flashes of alertness, and his weary resignation are recorded in a few almost brutal strokes. Here Picasso has given us the true portrait of Ambroise Vollard; it is a fitting tribute, and a testimony of a most fruitful encounter.

The publishers wish to thank Galerie Berggruen, 70 Rue de l'Université, Paris 7, for making available one series of originals for this volume. The photos are by Ralph Kleinhempel, Hamburg.

NOTES

[1] The number of source books on Vollard is astonishingly small. We have a few interesting papers, and two valuable books—*Souvenirs d'un marchand de tableaux* by Ambroise Vollard, Paris 1937, and *Ambroise Vollard, Editeur, 1867–1939, an Appreciation and Catalogue* by Una E. Johnson, New York 1944. Vollard's own book is a fascinating account of a great period and of a significant career. Una Johnson's book, written at a time which offered the worst conceivable conditions for such an undertaking, gives us a succinct scientific survey of Vollard's life and work. The author has explored the entire material with great care, and as a result her book, which includes an extensive catalogue of Vollard's publications, is extremely useful. It has today become indispensable to every collector, museum curator, librarian, and art dealer. Its defects (for instance, it does not mention the *Suite Vollard*) could easily be remedied in a new edition.

[2] Ambroise Vollard, *Souvenirs d'un marchand de tableaux*, Paris 1937, p. 305.

[3] *Ibid.*, p. 311.

[4] Texts by Pierre de Ronsard, Charles Baudelaire, François Villon, Saint Francis, and the *Odyssey* are illustrated by Emile Bernard. Octave Mirbeau's *Dingo* and Vollard's *Vie de sainte Monique* are illustrated by Pierre Bonnard. Maurice Denis supplies drawings for the *Imitation of Christ* and for the *Poems* by Francis Thompson. Raoul Dufy executes no fewer than ninety-four large etchings of Marseille and its Vieux Port for Eugène Montfort's *La belle enfant ou l'Amour à 40 ans*. And the exuberance of Ronsard's *Livret de Folastries* is marvellously reflected in Maillol's etchings.

[5] Vollard's monographs on Cézanne and Renoir won the respect of art historians, and his poem *Sainte Monique* (illustrated by Bonnard) and his topical satires in the manner of Jarry's *Père Ubu* (splendidly illustrated by Rouault) demonstrated his literary talent. In 1936, in the course of his visit to America, Little, Brown, and Co. issued his memoirs under the title of *Recollections of a Picture Dealer*. The French edition was published a year later by Albin Michel in Paris. These memoirs are a witty and interesting account of an adventurous career; they give us a good picture of Vollard the connoisseur, the art dealer, the publisher, the writer, and the man.

[6] Fernande Olivier, *Picasso et ses amis*, Paris 1933, p. 58.

[7] At the outbreak of the war Kahnweiler was forced to leave Paris, as an 'enemy alien'. During his absence Picasso's dealer was first Léonce, and after 1918, Paul Rosenberg. Since 1940—with the exception of the years 1945 and 1946—the Louise Leiris gallery (D. H. Kahnweiler) has again been Picasso's exclusive dealer. Cf. Catalogue of the Picasso Exhibition 1900–1955, Munich-Cologne-Hamburg 1955–56, p. 51.

[8] The numbers preceded by the letter G refer to Bernard Geiser, *Picasso peintre-graveur, Catalogue illustré de l'œuvre gravé et lithographié 1899–1931*, Bern 1933.

[9] In 1917 Picasso painted the curtain, settings, costumes, and figurines for Diaghilev's production of *Parade* (text by Jean Cocteau, music by Eric Satie).

[10] From 'Huit entretiens avec Picasso' by Daniel Henry Kahnweiler, in *Le Point*, October 1952.

[11] The sugar process is described in detail by John Buckland-Wright, *Graphis*, No. 24, Zurich 1948 (pp. 310, 312, 314–18, 405, 406).

LIST OF PLATES

37. *c. March 1933* (Sculptor Seated, Reclining Model, and Statue of Man). Etching. *c.* 1933. $10\frac{1}{2} \times 7\frac{5}{8}''$

38. *c. March 1933* (Seated Model and Sculptor Studying Sculptured Head). Etching. *c.* 1933. $10\frac{1}{2} \times 7\frac{5}{8}''$

39. *c. March 1933* (Sculptor and Model Seated before a Sculptured Head). Etching. *c.* 1933. $10\frac{1}{2} \times 7\frac{5}{8}''$

40. *c. March 1933* (Sculptor and Model Viewing Statue of Seated Woman). Dry point. *c.* 1933. $12\frac{7}{16} \times 7\frac{1}{4}''$

41. *Paris, March 20, 1933* (Two Sculptors, Male and Female Model, and Sculpture). Etching. 1933. $7\frac{5}{8} \times 10\frac{1}{2}''$

42. *Paris, March 21, 1933* (Two Women before Sculptured Head). Etching. 1933. $10\frac{1}{2} \times 7\frac{5}{8}''$

43. *Paris, March 21, 1933* (Seated Nude with Painting and Sculptured Head). Etching. 1933. $10\frac{9}{16} \times 7\frac{5}{8}''$

44. *Paris, March 21 [?], 1933* (Sculptor with Fishbowl, and Nude Seated before a Sculptured Head). Etching. 1933. $10\frac{1}{2} \times 7\frac{5}{8}''$

45. *Paris, March 23, 1933* (Sculptor and Seated Model before a Sculptured Head). Etching. 1933. $10\frac{1}{2} \times 7\frac{5}{8}''$

46. *Paris, March 25, 1933* (Young Sculptor at Work). Etching. 1933. $10\frac{1}{2} \times 7\frac{5}{8}''$

47. *Paris, March 25, 1933* (Sculptor Working from a Model). Combined technique. 1933. $10\frac{1}{2} \times 7\frac{5}{8}''$

48. *Paris, March 26, 1933* (Seated Sculptor and Two Sculptured Heads). Etching. 1933. $10\frac{1}{2} \times 7\frac{5}{8}''$

49. *Paris, March 26, 1933* (Sculptor Examining Sculptured Head). Etching. 1933. $10\frac{1}{2} \times 7\frac{5}{8}''$

50. *Paris, March 27, 1933* (Sculptor, Model Wearing Mask, and Statue of Standing Nude). Etching. 1933. $10\frac{1}{2} \times 7\frac{5}{8}''$

51. *Paris, March 27, 1933* (Sculptor, Model, and Statue of a Nude Holding Drapery). Etching. 1933. $10\frac{1}{2} \times 7\frac{5}{8}''$

52. *Paris, March 7, 1933* (Three Nude Men, Standing). Etching. 1933. $10\frac{5}{8} \times 7\frac{5}{8}''$

53. *Paris, March 30, 1933* (Sculptor and Reclining Model at Window Viewing a Sculptured Torso). Etching. 1933. $7\frac{5}{8} \times 10\frac{1}{2}''$

54. *Paris, March 30, 1933* (Sculptor and Model Watching Three Jugglers). Etching. 1933. $7\frac{5}{8} \times 10\frac{1}{2}''$

55. *Paris, March 30, 1933* (Sculptor, Reclining Model, and Sculpture of a Horse and Youth). Etching. 1933. $7\frac{5}{8} \times 10\frac{9}{16}''$

56. *Paris, March 30, 1933* (Sculptor and Model with Sculpture of Bull and Two Bacchants). Etching. 1933. $7\frac{3}{4} \times 10\frac{1}{2}''$

57. *Paris, March 31, 1933* (Sculptor and Reclining Model Viewing Sculpture of Bull and Two Horses). Etching. 1933. $7\frac{5}{8} \times 10\frac{1}{2}''$

58. *Paris, March 31, 1933* (Sculptor and Model with Statue of Centaur Kissing a Girl). Etching. 1933. $7\frac{5}{8} \times 10\frac{9}{16}''$

59. *Paris, March 31, 1933* (Sculptor Seated by a Window, Working from Model). Etching. 1933. $7\frac{5}{8} \times 10\frac{1}{2}''$

60. *Paris, March 31 [?], 1933* (Sculptor at Rest, Reclining Model, and Sculpture). Etching. 1933. $7\frac{5}{8} \times 10\frac{1}{2}''$

61. *Paris, April 1, 1933* (Model and Sculptured Head). Etching. 1933. $10\frac{1}{2} \times 7\frac{5}{8}''$

62. *Paris, April 2, 1933* (Sculptor and Reclining Model Viewing Sculptured Head). Etching. 1933. $7\frac{5}{8} \times 10\frac{1}{2}''$

63. *Paris, April 3, 1933* (Sculptor and Reclining Model by a Window Viewing a Sculptured Head). Etching. 1933. $7\frac{5}{8} \times 10\frac{1}{2}''$

64. *Paris, April 3, 1933* (Reclining Sculptor and Model by a Window, Viewing a Sculpture of Two Fighting Horses). Etching. 1933. $7\frac{5}{8} \times 10\frac{1}{2}''$

65. *Paris, April 4, 1933* (Sculptor and Model Reclining by a Window, and Sculptured Head). Etching. 1933. $7\frac{5}{8} \times 10\frac{1}{2}''$

66. *Paris, April 5, 1933* (Model Kneeling by a Window Viewing a Sculpture of Nude Figures and a Rearing Horse). Etching. 1933. $11\frac{11}{16} \times 14\frac{7}{16}''$

67. *Paris, April 6, 1933* (Three Nudes Seated by a Window with Basket of Flowers). Etching. 1933. $14\frac{7}{16} \times 11\frac{3}{4}''$

68. *Paris, April 7, 1933* (Sculptor and Model by a Window). Etching. 1933. $14\frac{1}{2} \times 11\frac{11}{16}''$

69. *Paris, April 8, 1933* (Sculptor and Model by a Window, with Overturned Sculptured Head). Etching. 1933. $14\frac{7}{16} \times 11\frac{3}{4}''$

70. *Paris, April 11, 1933* (Heads of Sculptor and Model, and Statue of a Striding Youth). Etching. 1933. $10\frac{1}{2} \times 7\frac{5}{8}''$

71. *Paris, May 3, 1933* (Young Girl with Drawing of Male Head, and Nude Seen from the Back). Combined technique. 1933. $14\frac{7}{8} \times 11\frac{9}{16}''$

72. *Paris, May 3, 1933* (Female Model and Two Sculptures). Etching. 1933. $14\frac{15}{16} \times 11\frac{11}{16}''$

73. *Paris, May 4, 1933* (Model and Sculptured Female Torso). Combined technique. 1933. $10\frac{9}{16} \times 7\frac{9}{16}''$

74. *Paris, May 4, 1933* (Model and Surrealist Sculpture). Etching. 1933. $10\frac{9}{16} \times 7\frac{5}{8}''$

75. *Paris, May 5, 1933* (Crouching Model, Nude, and Sculptured Head). Combined technique. 1933. $10\frac{1}{2} \times 7\frac{5}{8}''$

76. *Paris, May 5, 1933* (Sculpture of Seated Nude, Sculptured Head, and Vase of Flowers). Combined technique. 1933. $10\frac{1}{2} \times 7\frac{9}{16}''$

77. *c. 1934* (Three Costumed Figures Viewing a Sculptured Bust). Dry point. *c. 1934.* $11 \times 7\frac{3}{16}''$

78. *Paris, January 27, 1934* (Two Nudes). Etching. 1934. $10\frac{15}{16} \times 7\frac{13}{16}''$

79. *Paris, January 29, 1934* (Two Women). Etching. 1934. $10\frac{15}{16} \times 7\frac{13}{16}''$

80. *Picasso, Paris, January 29, 1934* (Two Nudes). Etching. 1934. $10\frac{15}{16} \times 7\frac{3}{4}''$

81. *Paris, March 2, 1934* (Sculptor and Statue of Three Female Dancers). Combined technique. 1934. $8\frac{7}{8} \times 12\frac{5}{16}''$

82. *Paris, March 10, 1934* (Four Models and a Sculptured Head). Combined technique. 1934. $8\frac{9}{16} \times 12\frac{1}{4}''$

THE MINOTAUR

83. *Paris, May 17, 1933* (Drinking Minotaur and Reclining Woman). Etching. 1933. $7\frac{5}{8} \times 10\frac{9}{16}''$

84. *Paris, May 18, 1933* (Minotaur Caressing Girl. At right, Flute-playing Boy and Girl at a Table with Fruits and Pitcher). Combined technique. 1933. $11\frac{3}{4} \times 14\frac{1}{2}''$

85. *Paris, May 18, 1933* (Drinking Minotaur and Sculptor with Two Models). Combined technique. 1933. $11\frac{11}{16} \times 14\frac{3}{8}''$

86. *Paris, May 18, 1933* (Girl Seated by Sleeping Minotaur). Combined technique. 1933. $7\frac{5}{8} \times 10\frac{1}{2}''$

87. *Paris, May 23, 1933* (Minotaur Assaulting Girl). Combined technique. 1933. $7\frac{5}{8} \times 10\frac{5}{8}''$

88. *Paris, May 26, 1933* (Dying Minotaur). Combined Technique. 1933. $7\frac{5}{8} \times 10\frac{1}{2}''$

89. *Paris, May 29, 1933* (Minotaur Defeated by Youth in Arena). Etching. 1933. $7\frac{5}{8} \times 10\frac{5}{8}''$

90. *Paris, May 30, 1933* (Dying Minotaur in Arena). Etching. 1933. $7\frac{3}{4} \times 10\frac{9}{16}''$

91. *Paris, June 16, 1933* (Minotaur with Girl in His Arms). Combined technique. 1933. $7\frac{5}{8} \times 10\frac{1}{2}''$

92. *Boisgeloup, June 18, 1933* (Minotaur, Drinking Sculptor, and Three Models). Combined technique. 1933. $11\frac{11}{16} \times 14\frac{3}{8}''$

93. *Boisgeloup, June 18, 1933* (Minotaur Kneeling over Sleeping Girl). Dry point. 1933. $11\frac{5}{8} \times 14\frac{3}{8}''$

THE BLIND MINOTAUR

94. *Boisgeloup, September 22, 1934* (Blind Minotaur Led by Girl with Bouquet of Wild Flowers. Upper left, Sketch (upside down) for 'Death of Marat'). Combined technique. 1934. $9\frac{15}{16} \times 13\frac{5}{8}''$

95. *c. October 1934* (Blind Minotaur Led by Girl with Fluttering Dove). Combined technique. *c. 1934.* $8\frac{7}{8} \times 12\frac{1}{4}''$

96. *Paris, October 23, 1934* (Blind Minotaur Led by Girl with Dove). Combined technique. 1934. $9\frac{5}{16} \times 11\frac{3}{4}''$

97. *c. 1935* (Blind Minotaur Led through the Night by Girl with Fluttering Dove). Combined technique. *c. 1935.* $9\frac{3}{4} \times 13\frac{11}{16}''$

PORTRAITS OF VOLLARD

98. *Portrait of Vollard I.* Aquatint. *c. 1937.* $13\frac{11}{16} \times 9\frac{3}{4}''$

99. *Portrait of Vollard II.* Combined technique. [1937]. $13\frac{11}{16} \times 9\frac{3}{4}''$

100. *Portrait of Vollard III.* Etching. [1937]. $13\frac{9}{16} \times 9\frac{5}{8}''$

THE PLATES

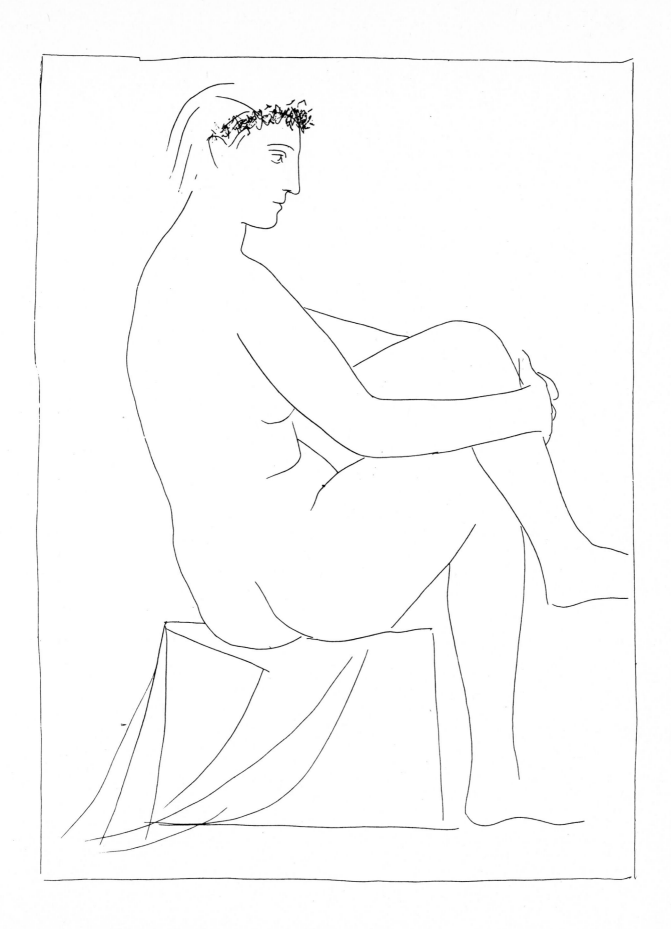

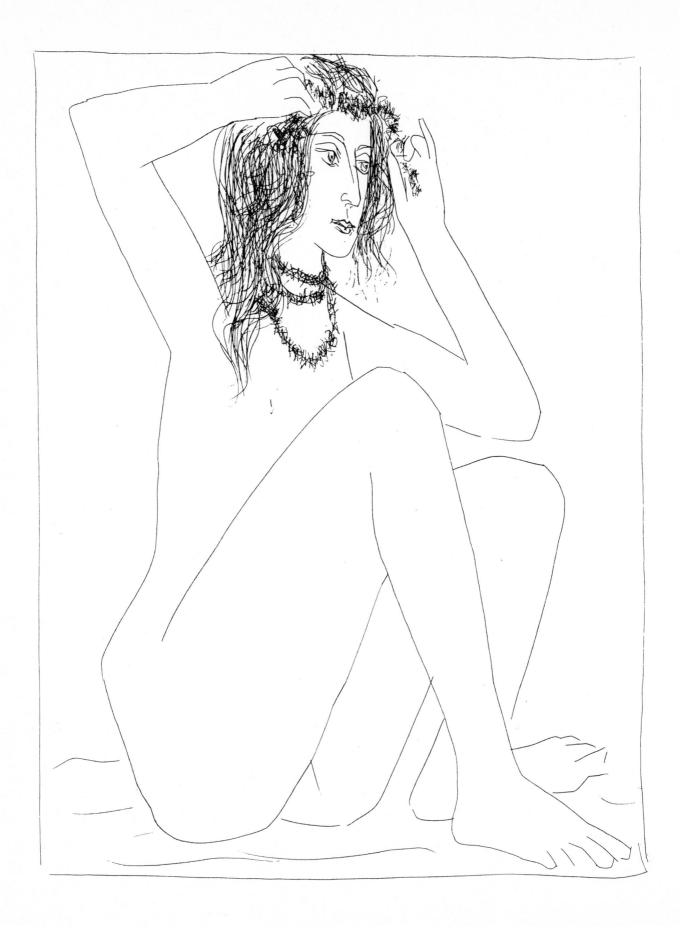

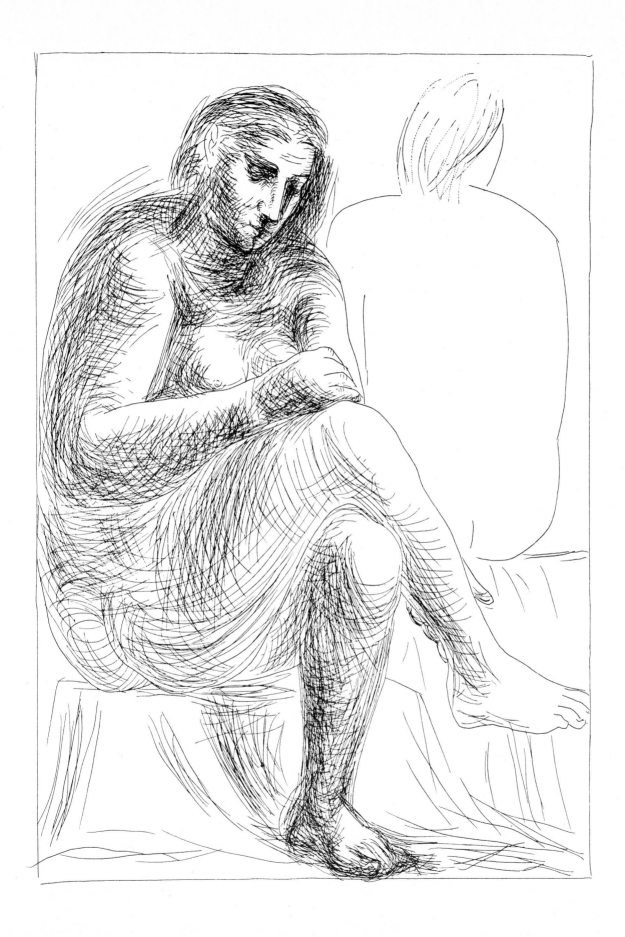

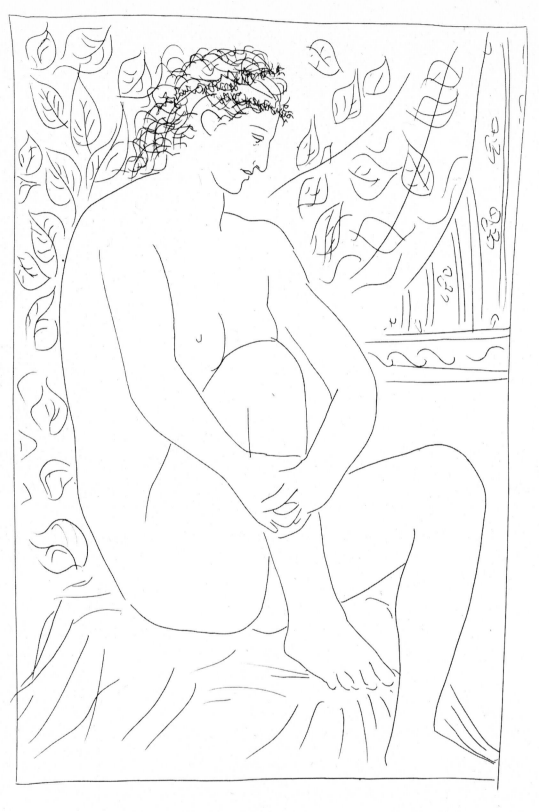

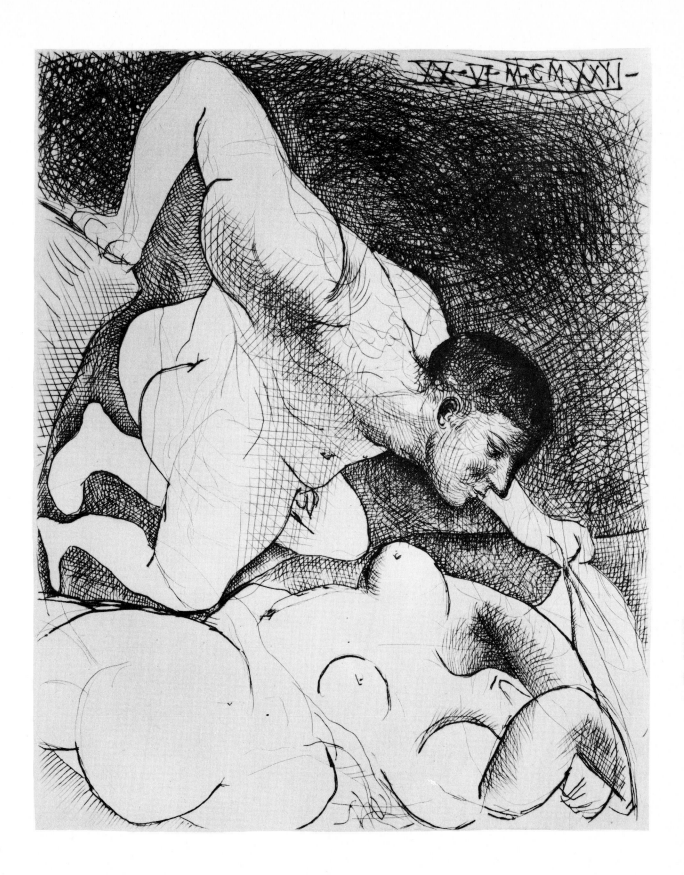

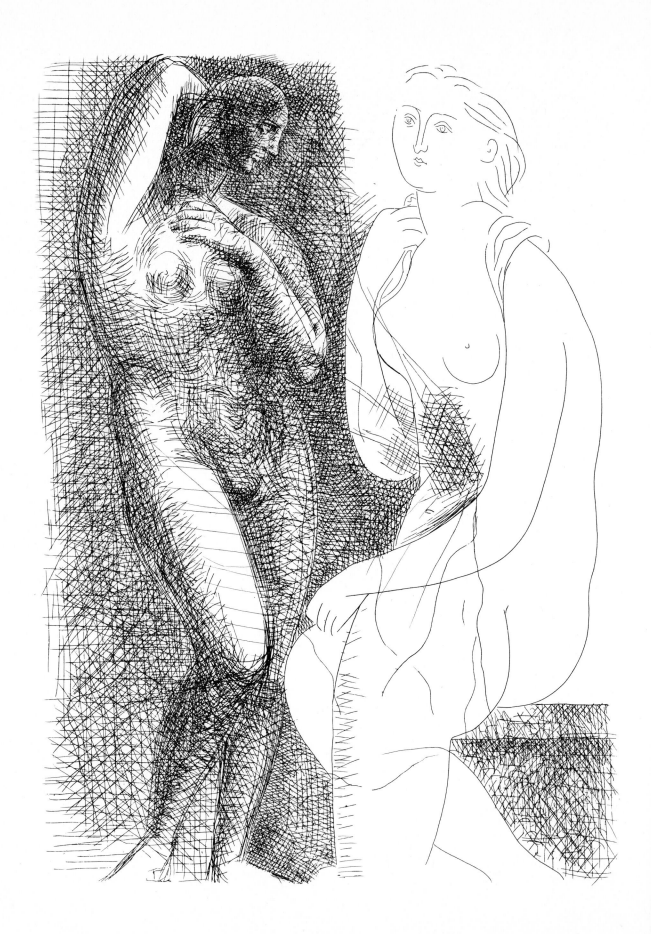

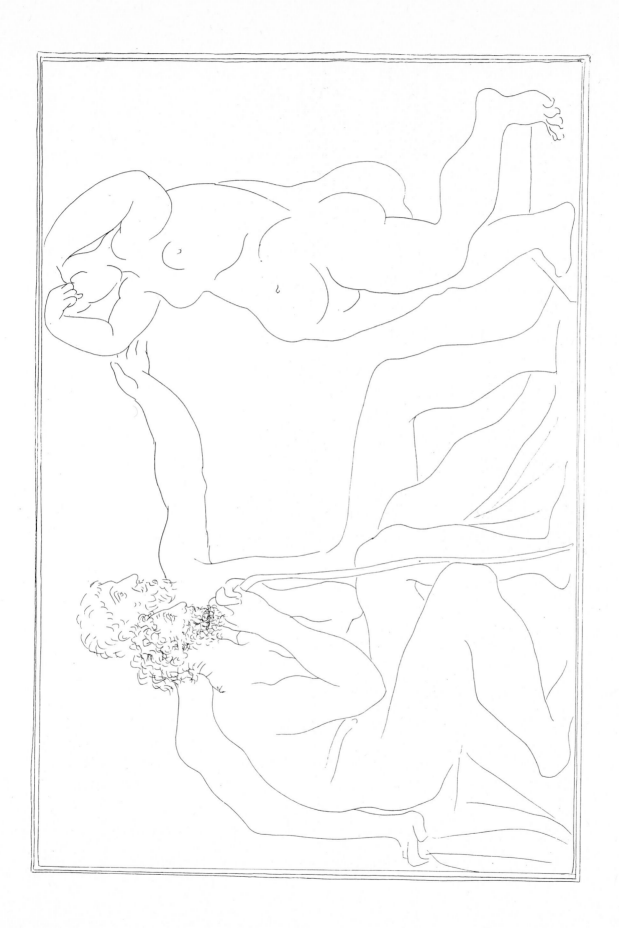

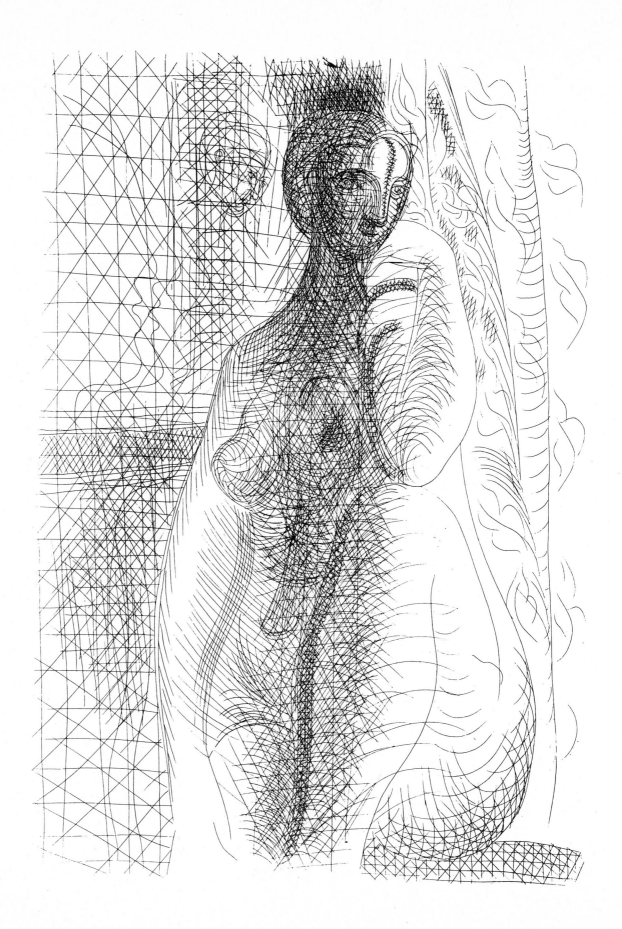

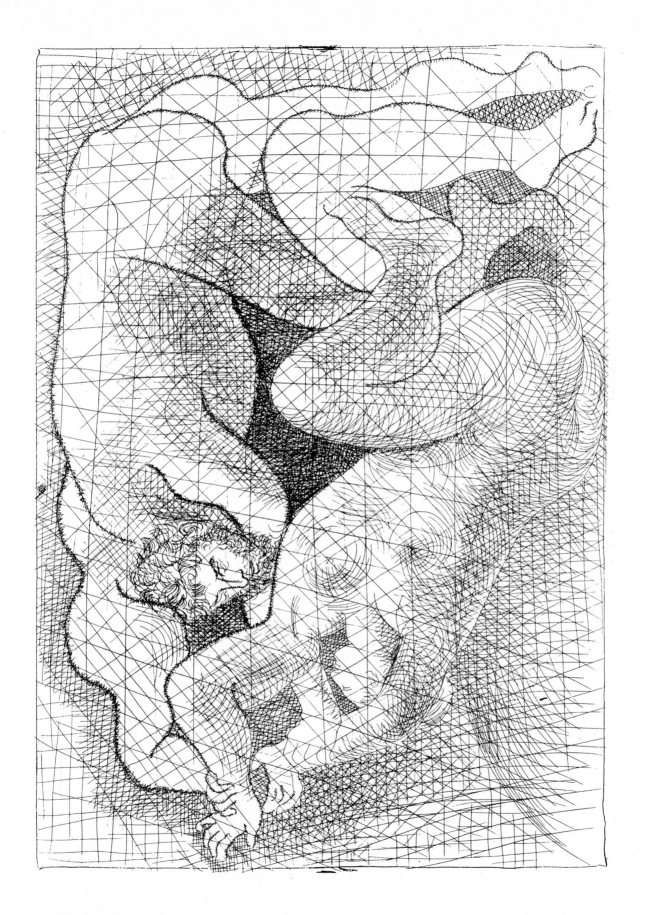

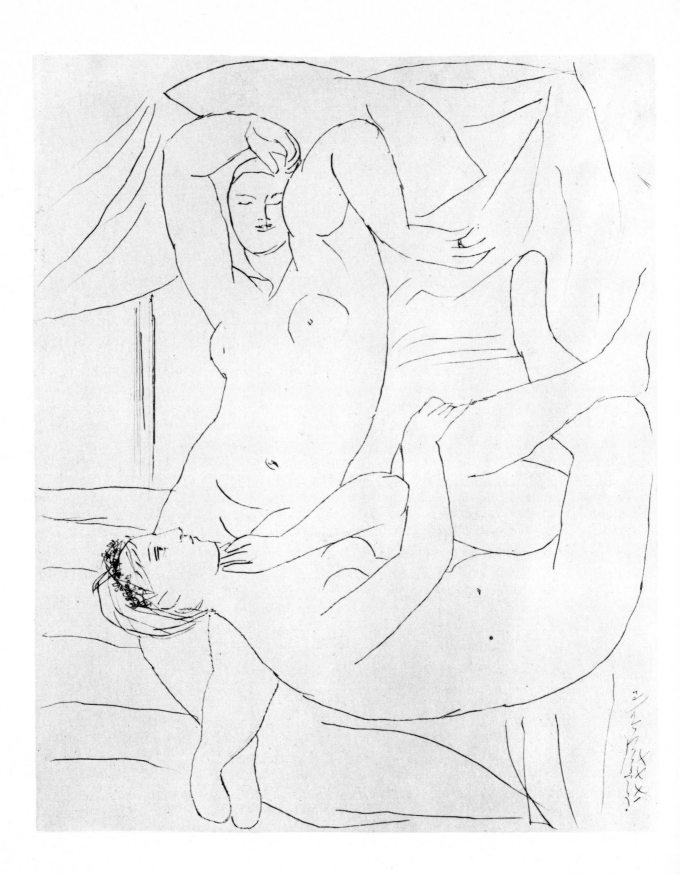

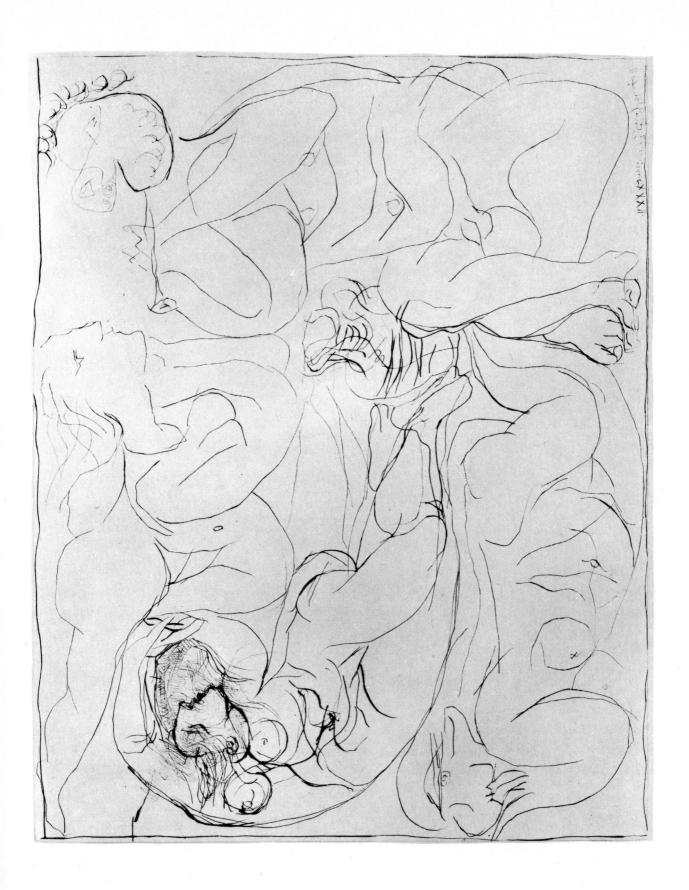

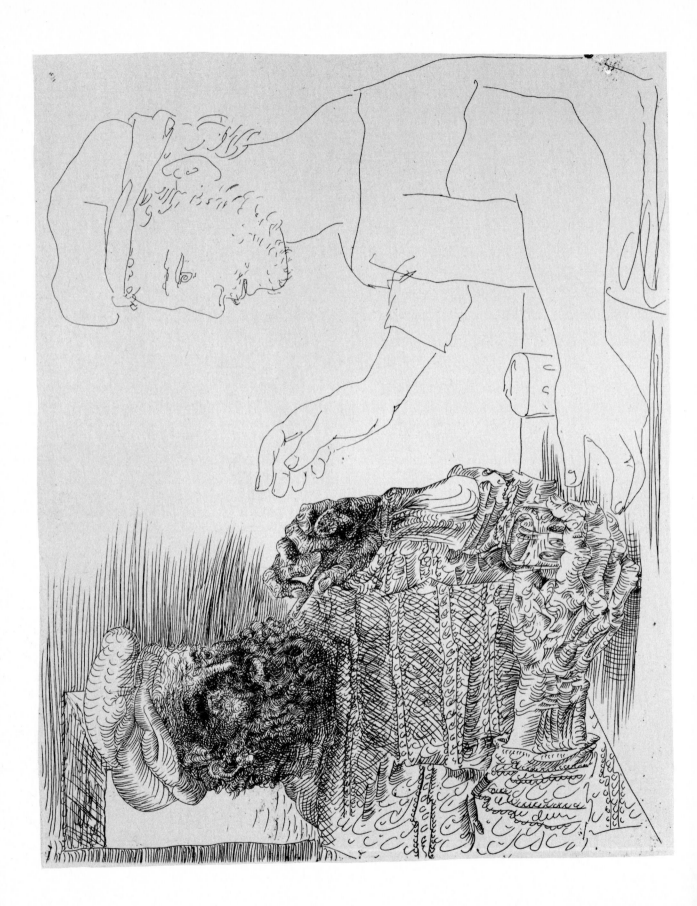

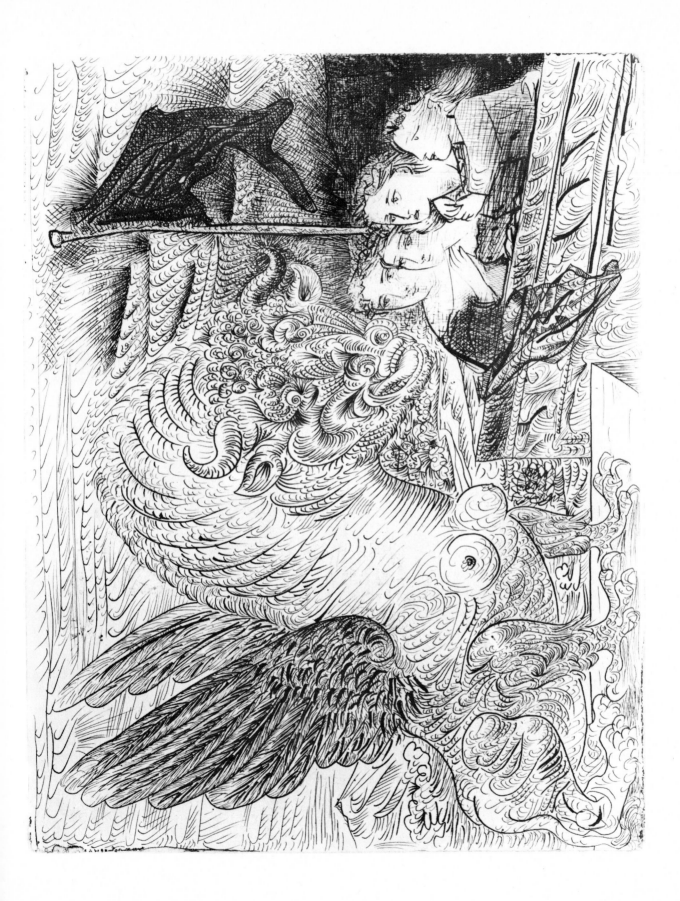

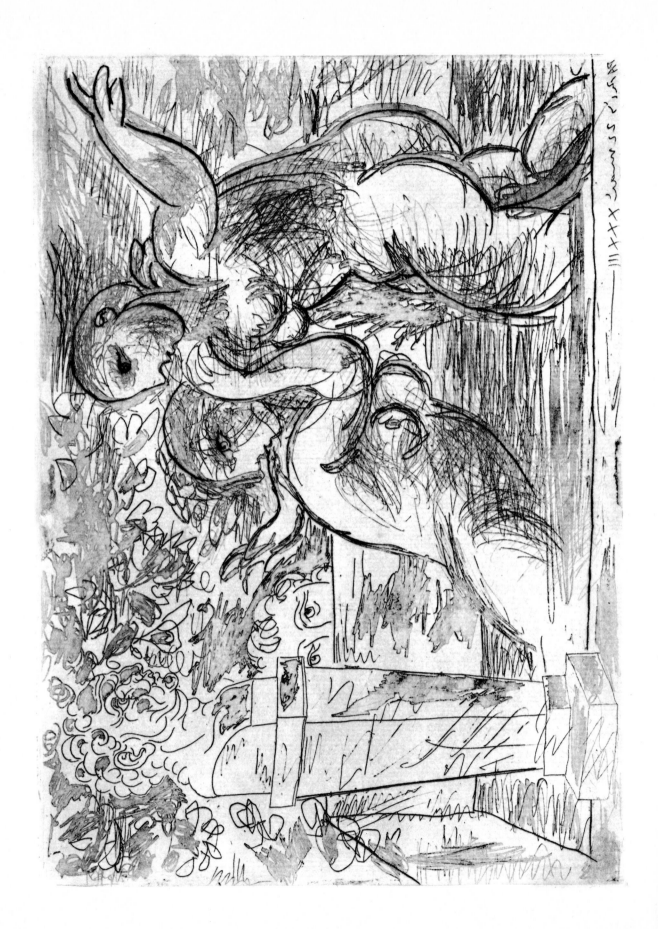

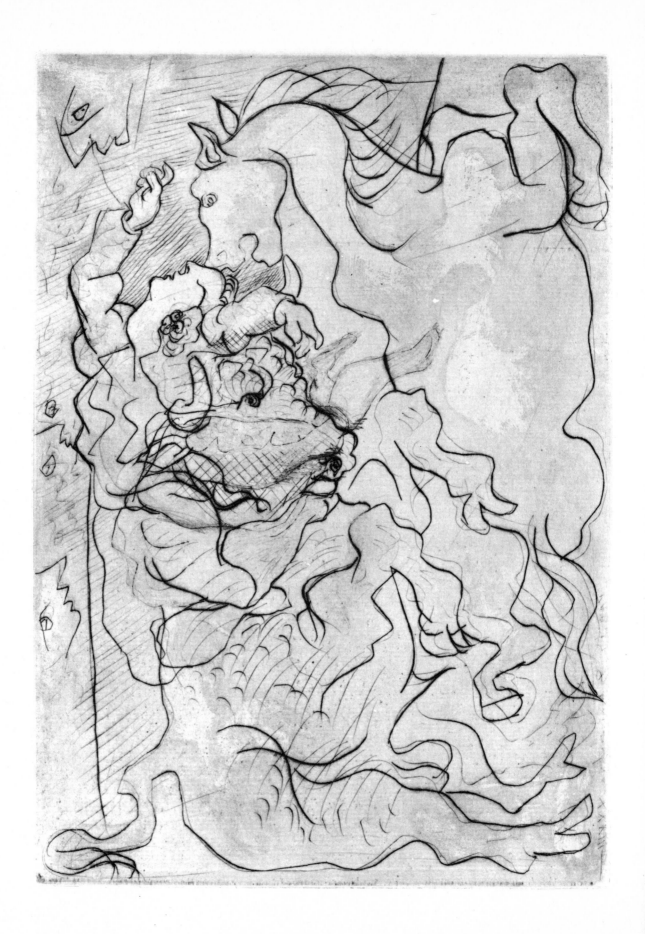

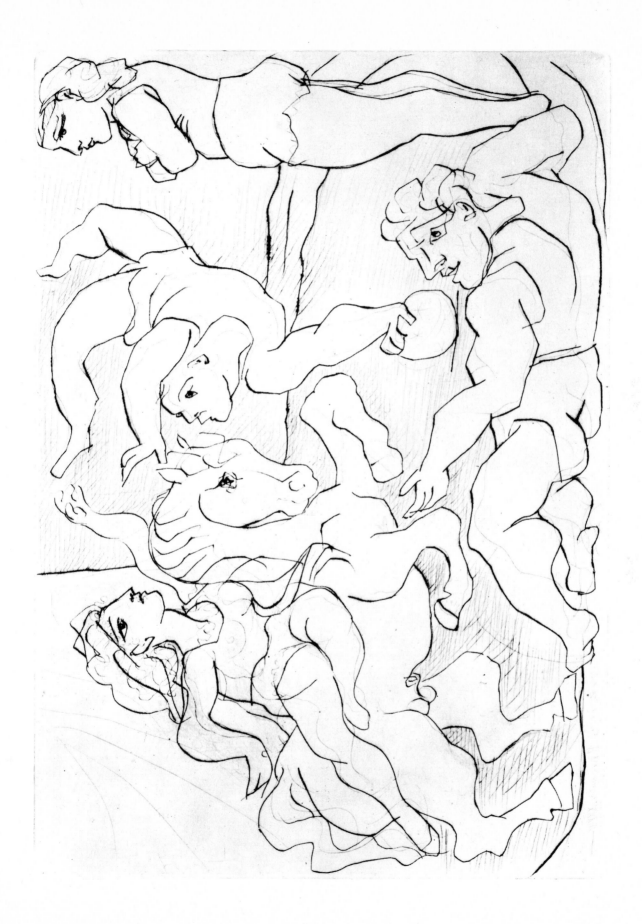

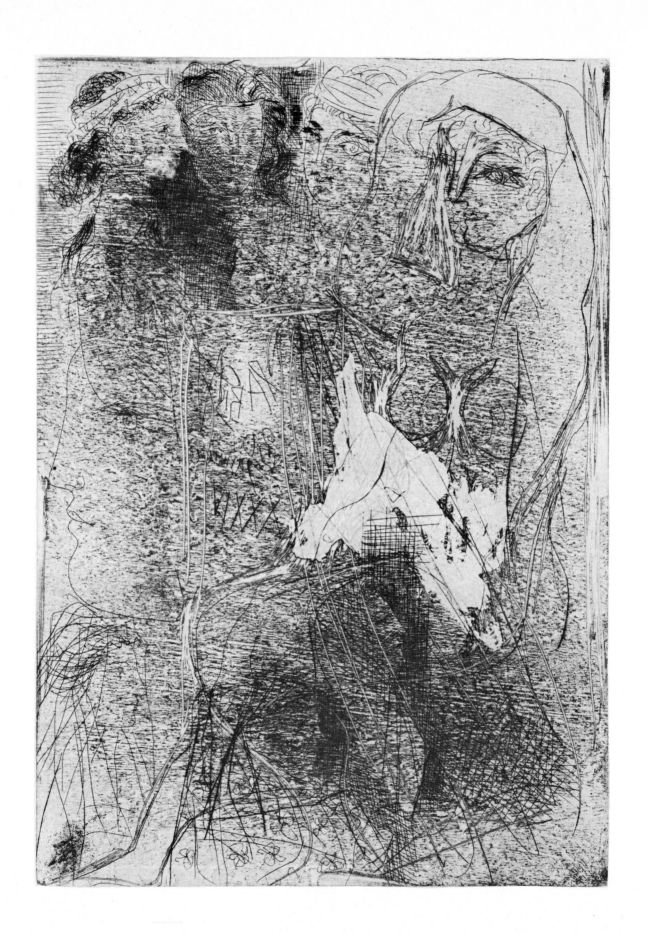

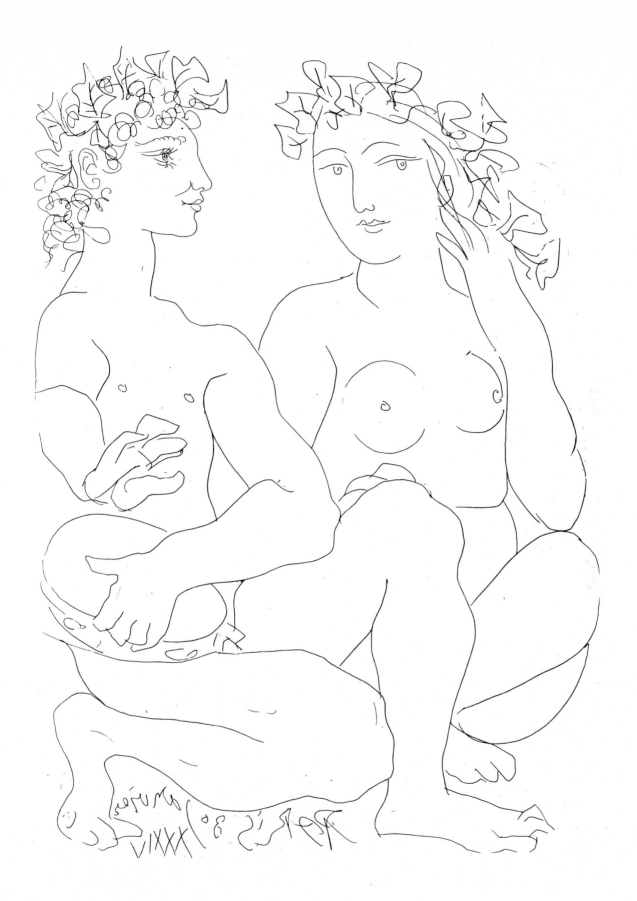

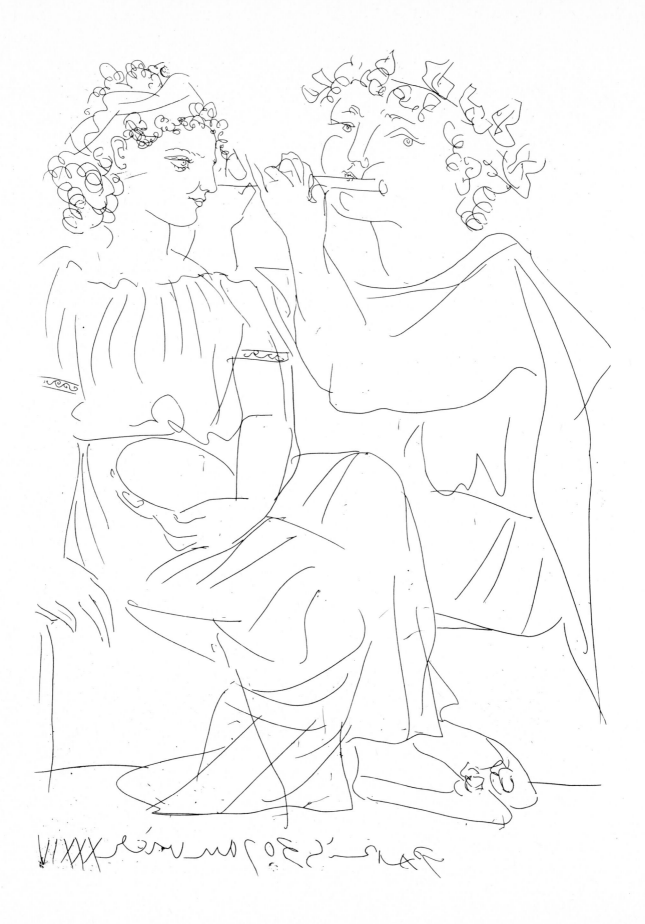

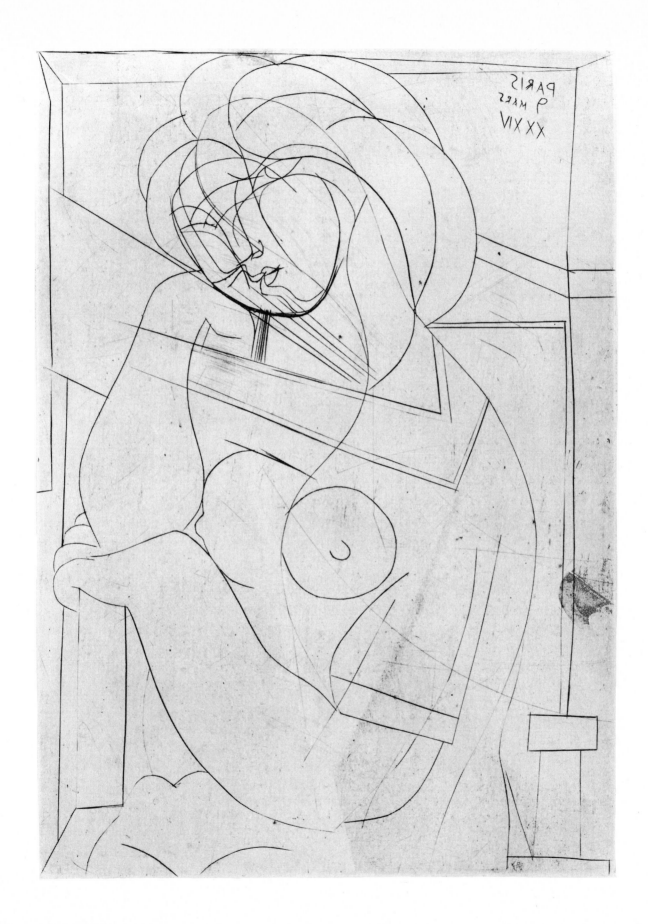

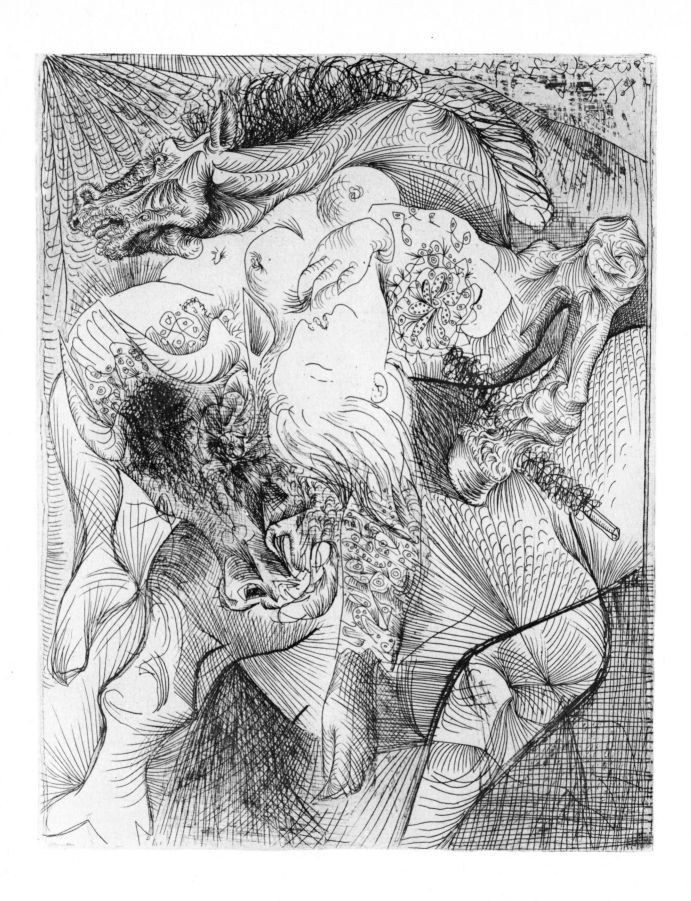

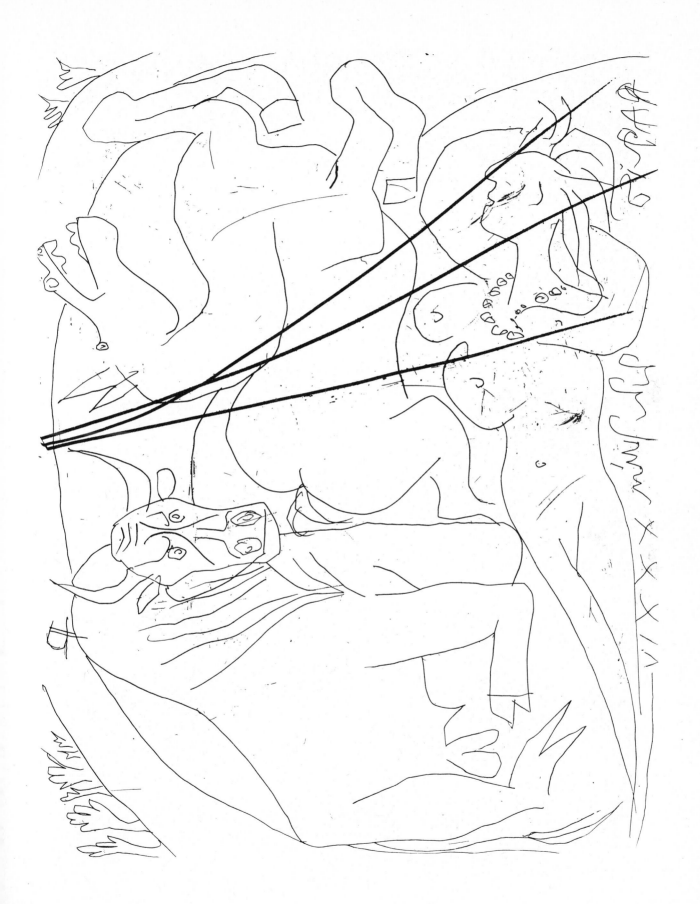

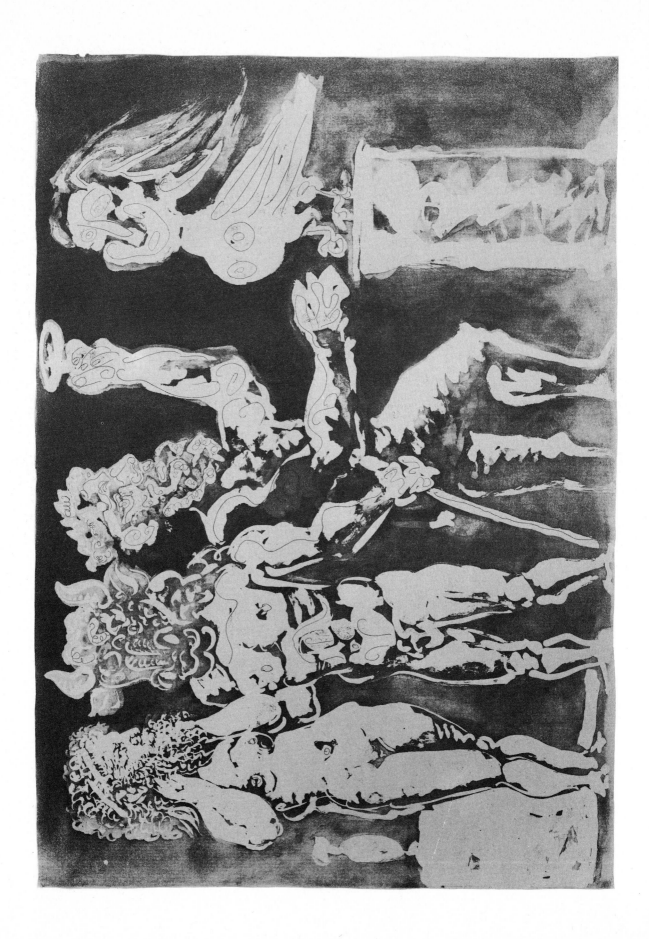

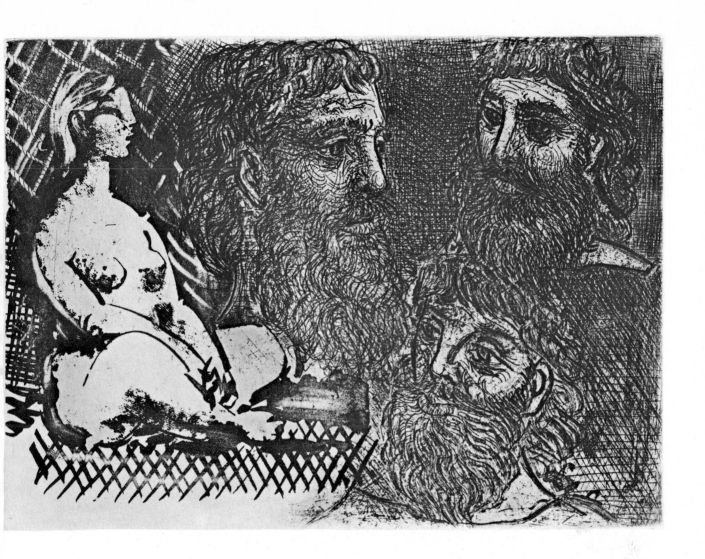

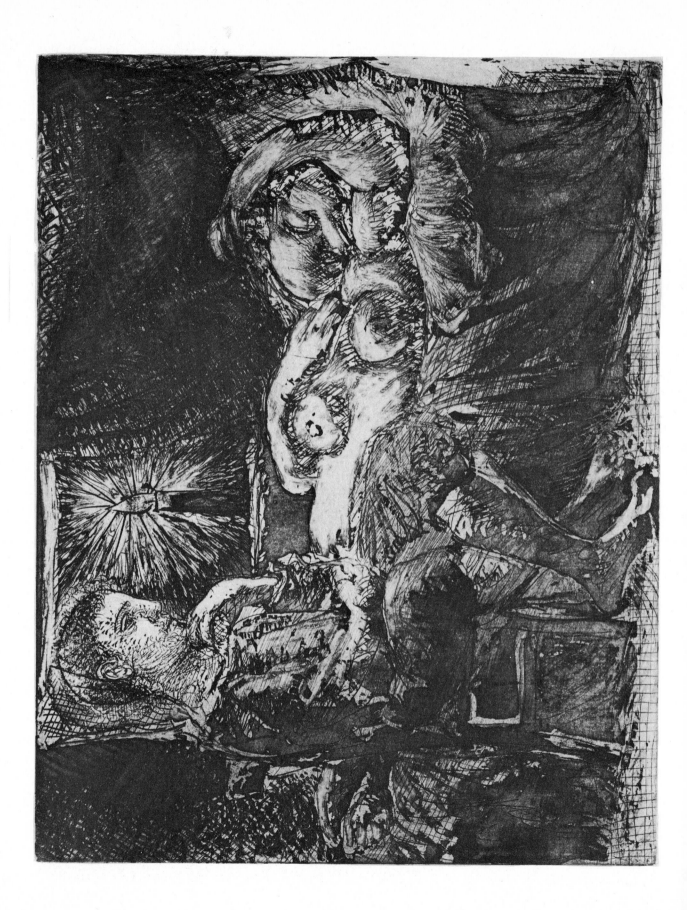

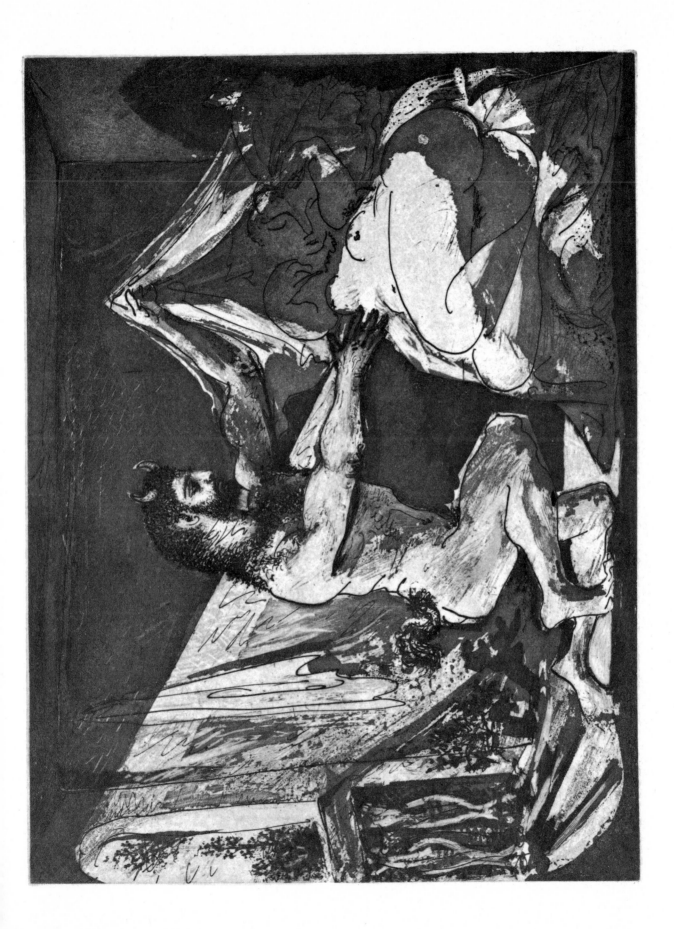

BATTLE OF LOVE

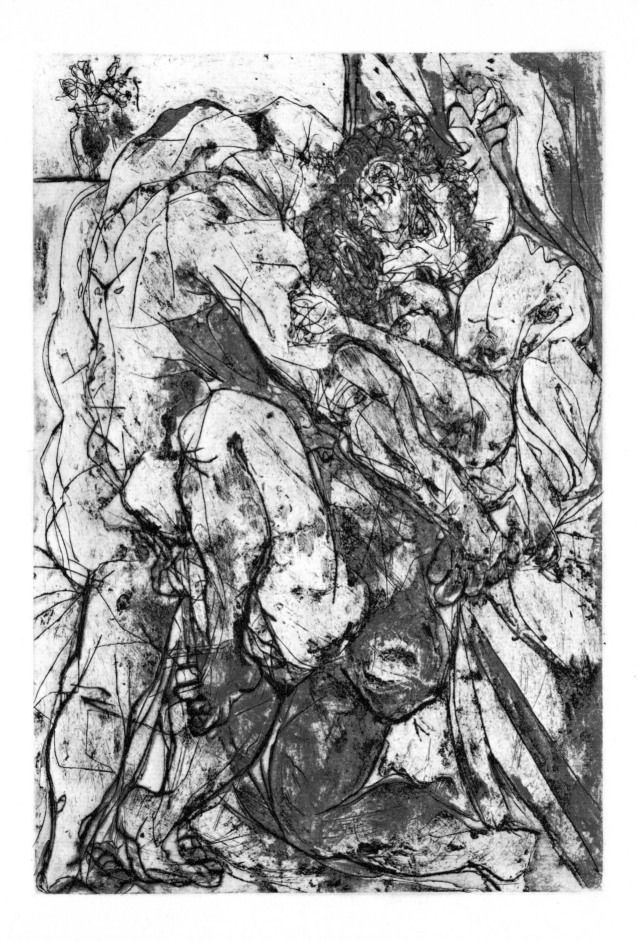

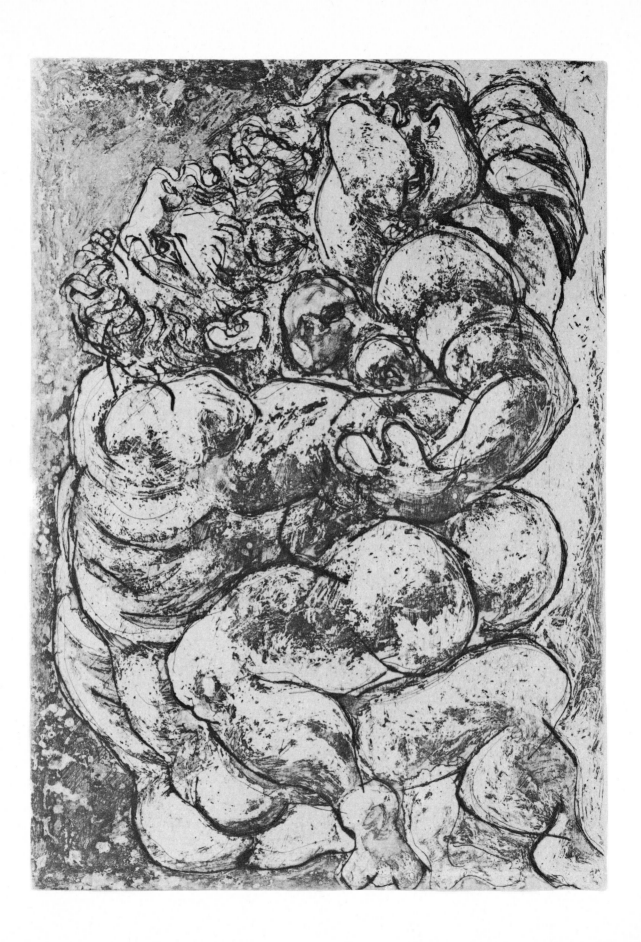

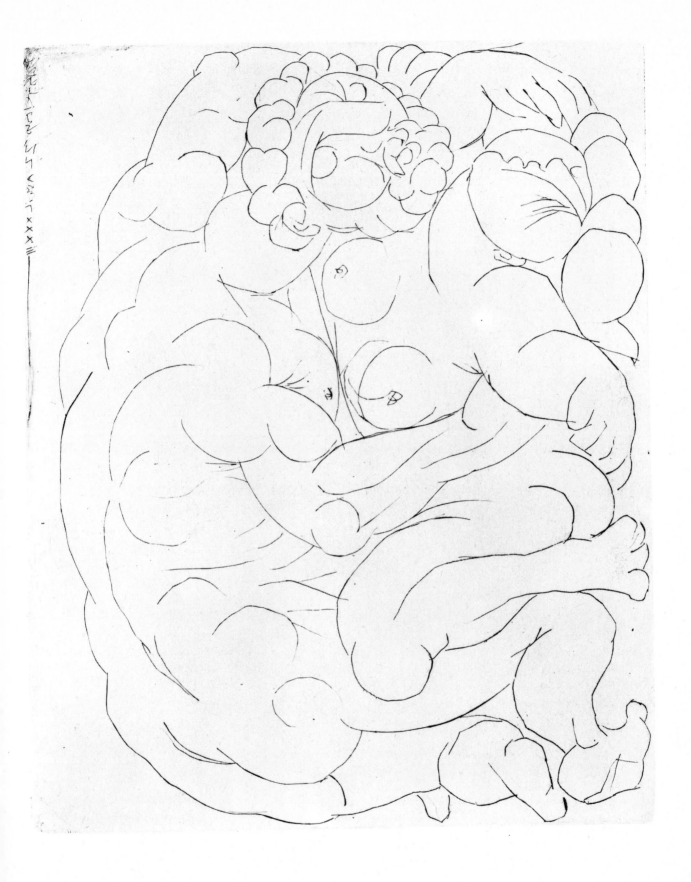

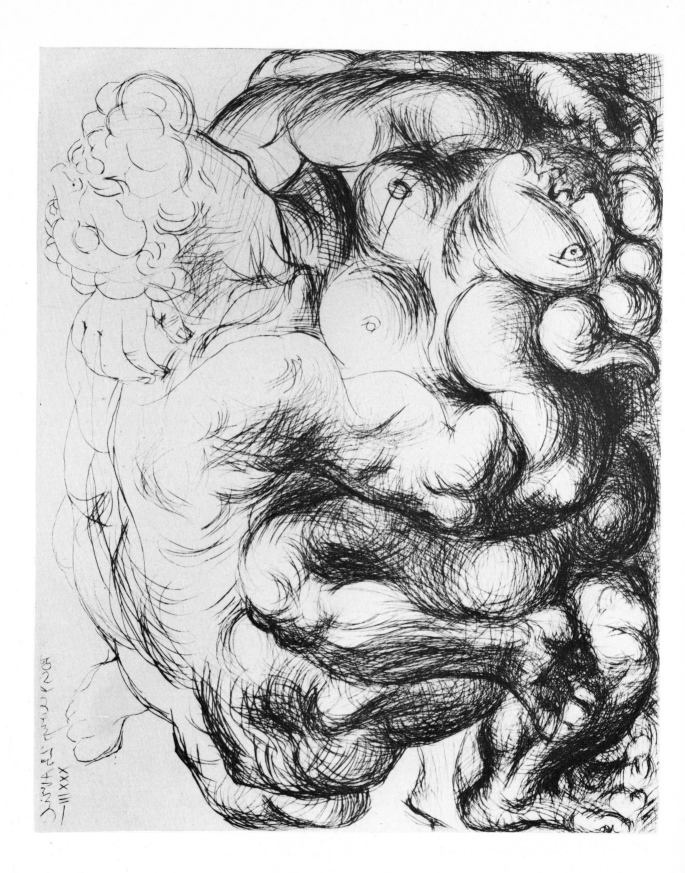

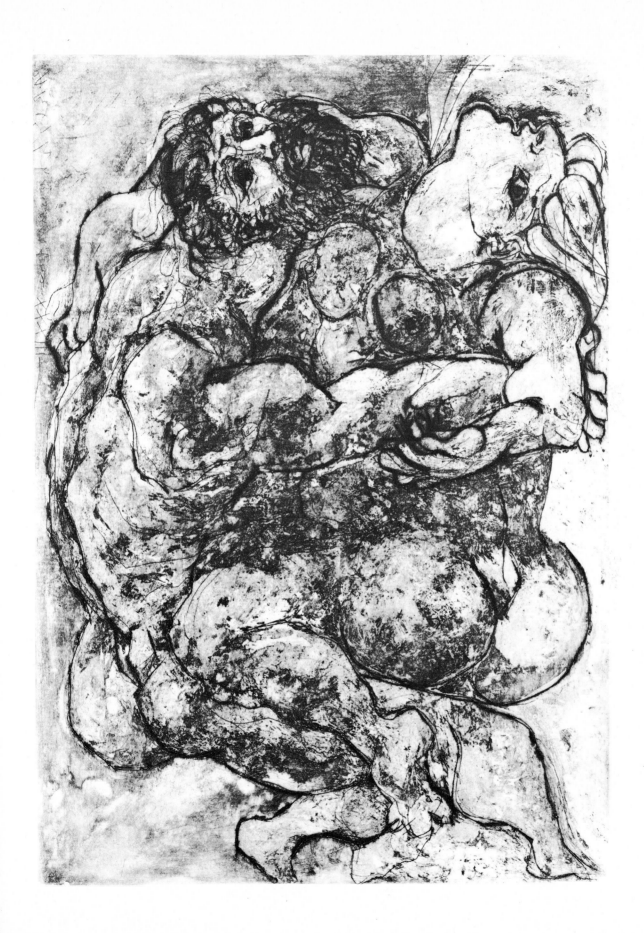

REMBRANDT

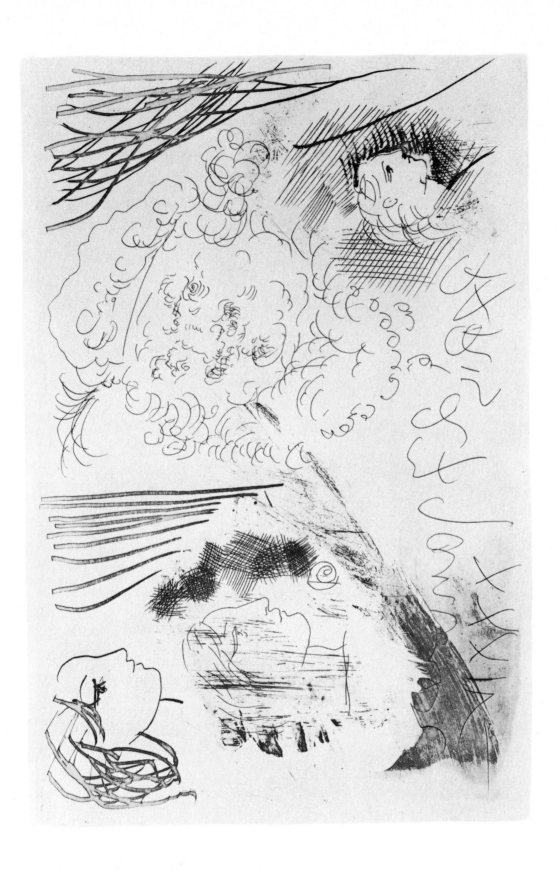

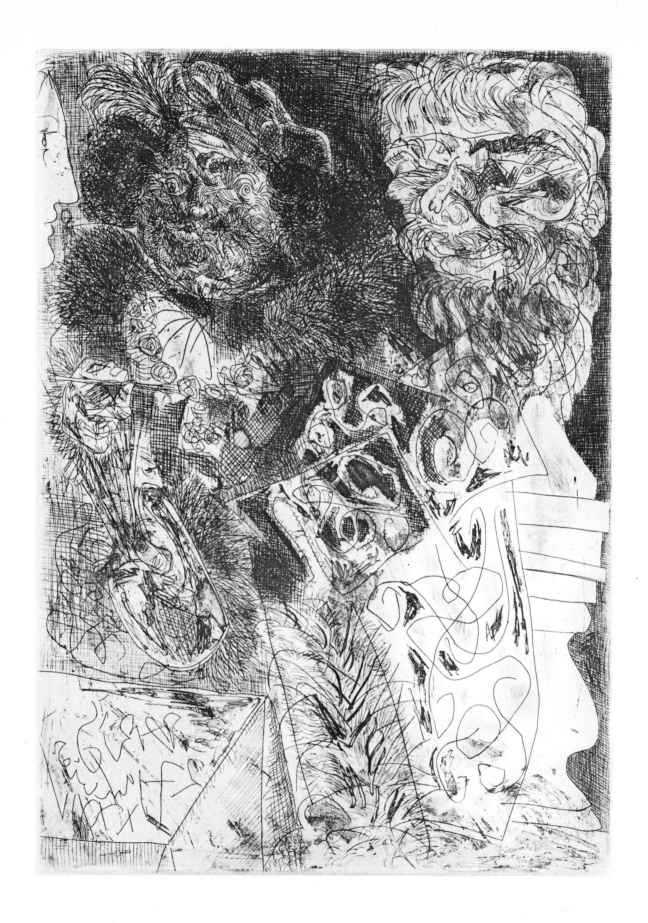

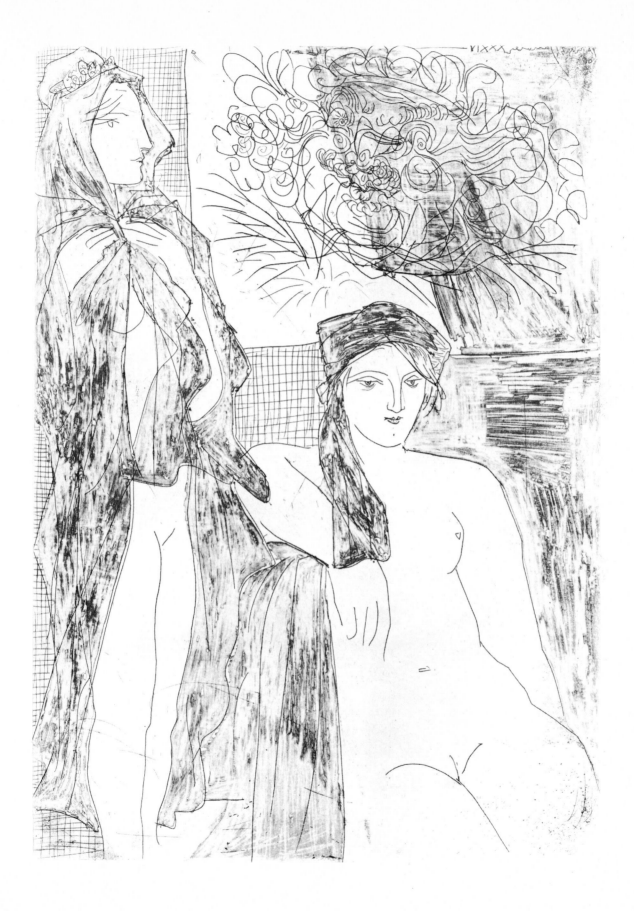

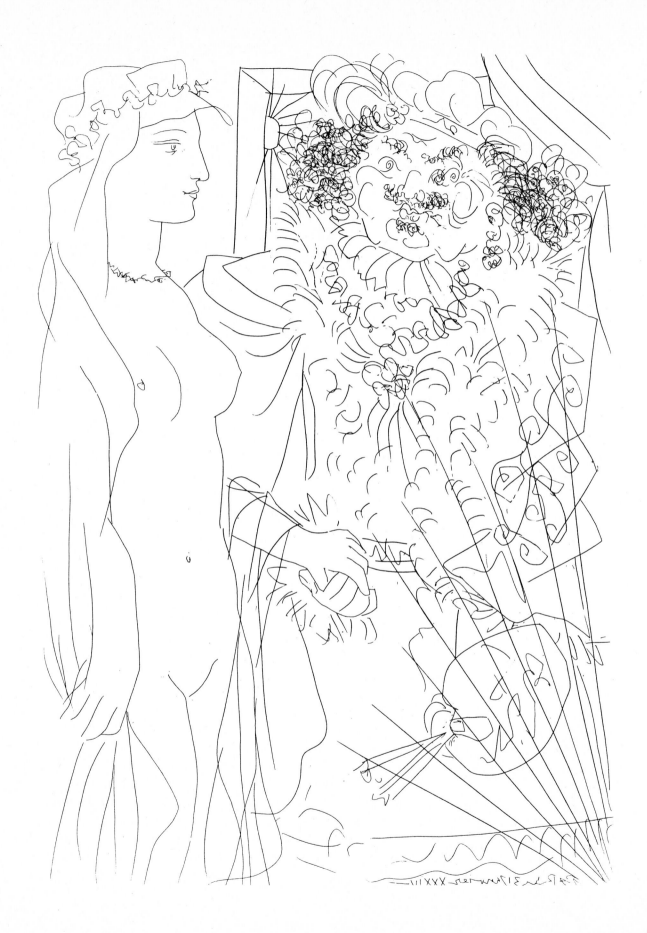

THE SCULPTOR'S STUDIO

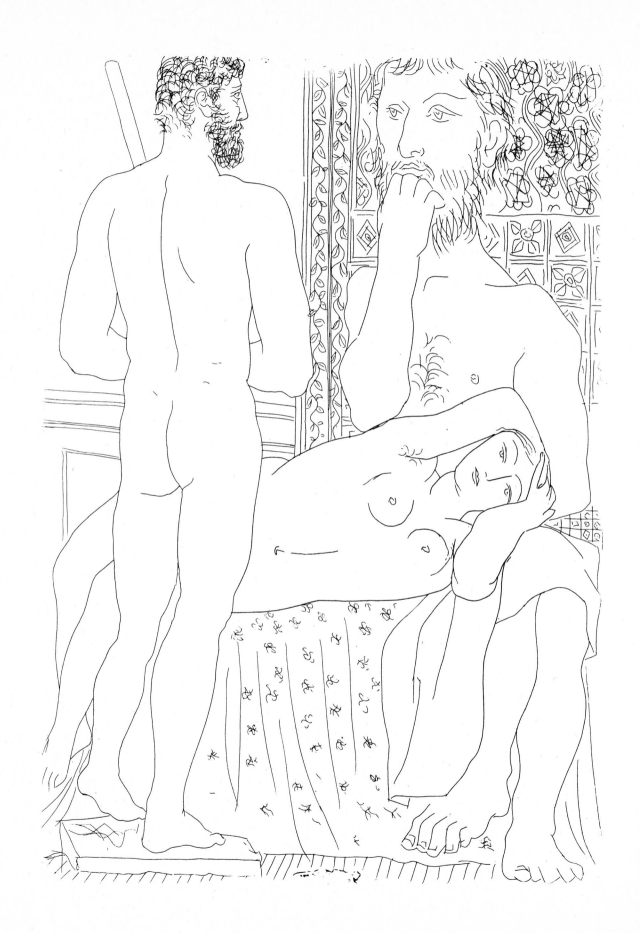

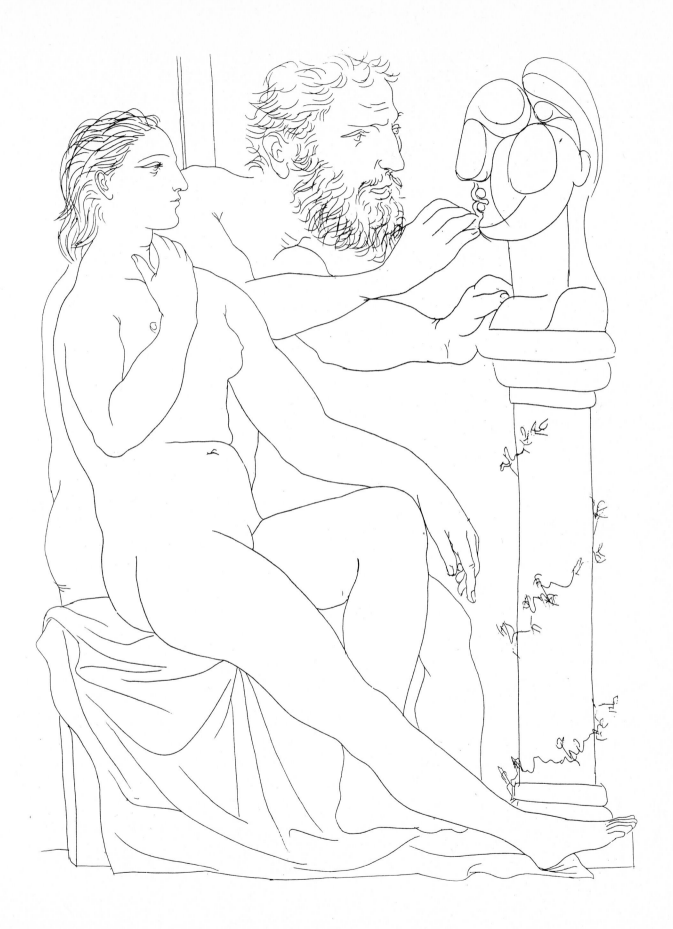

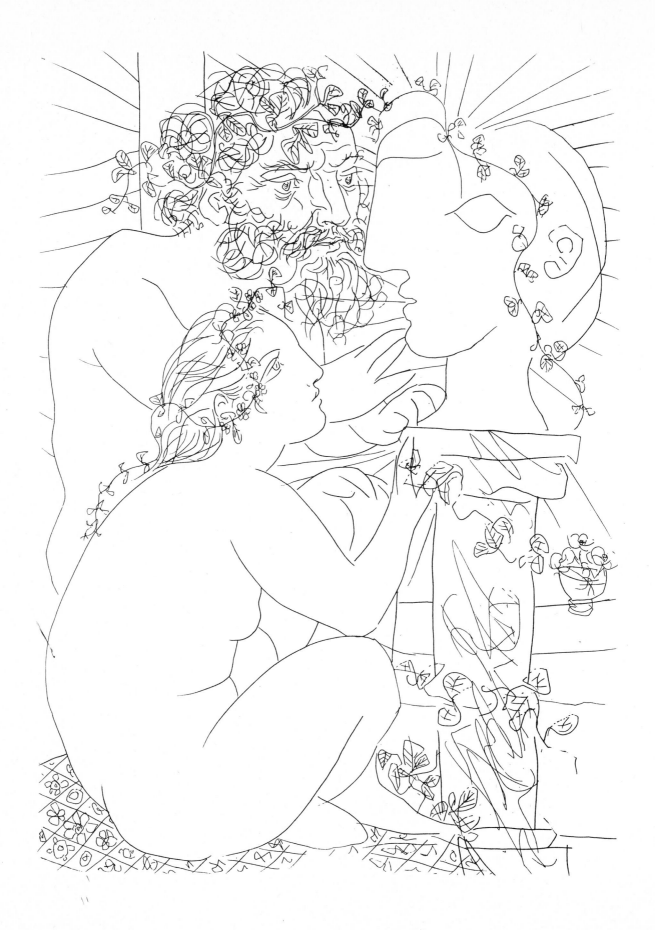

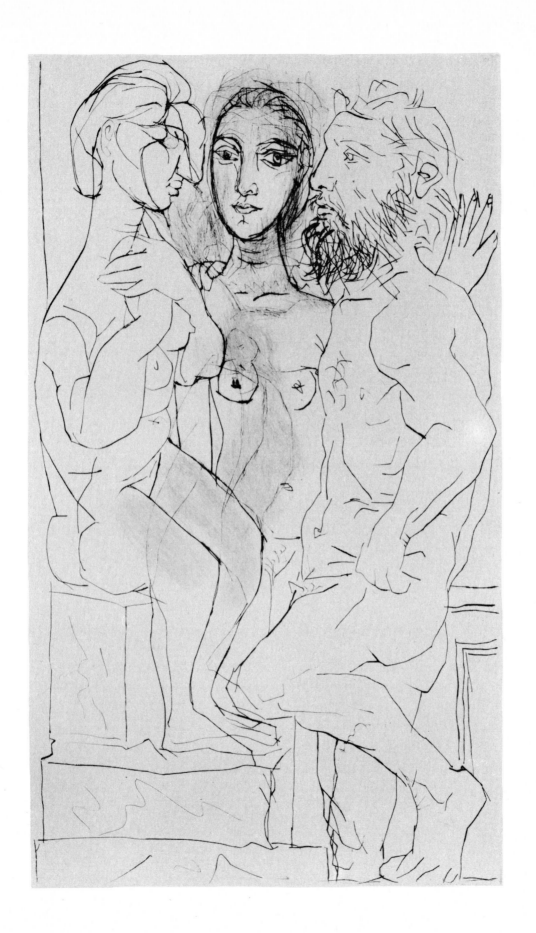

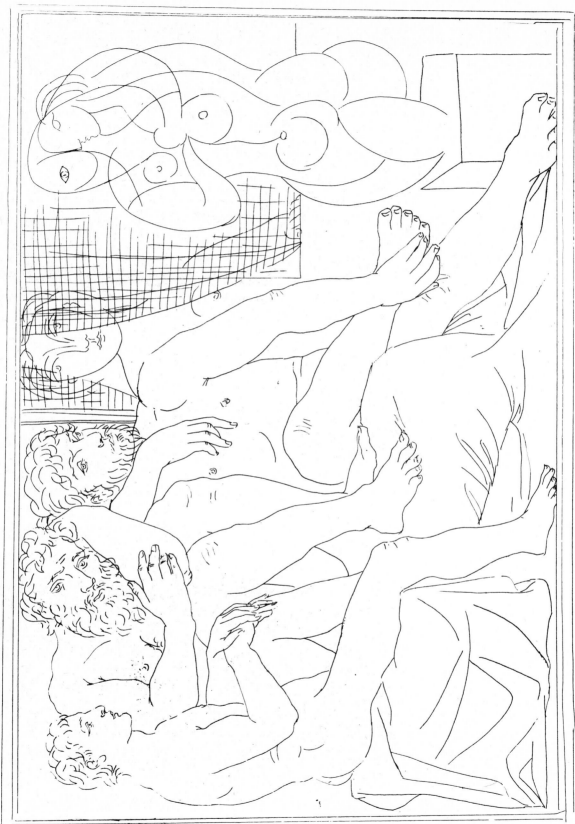

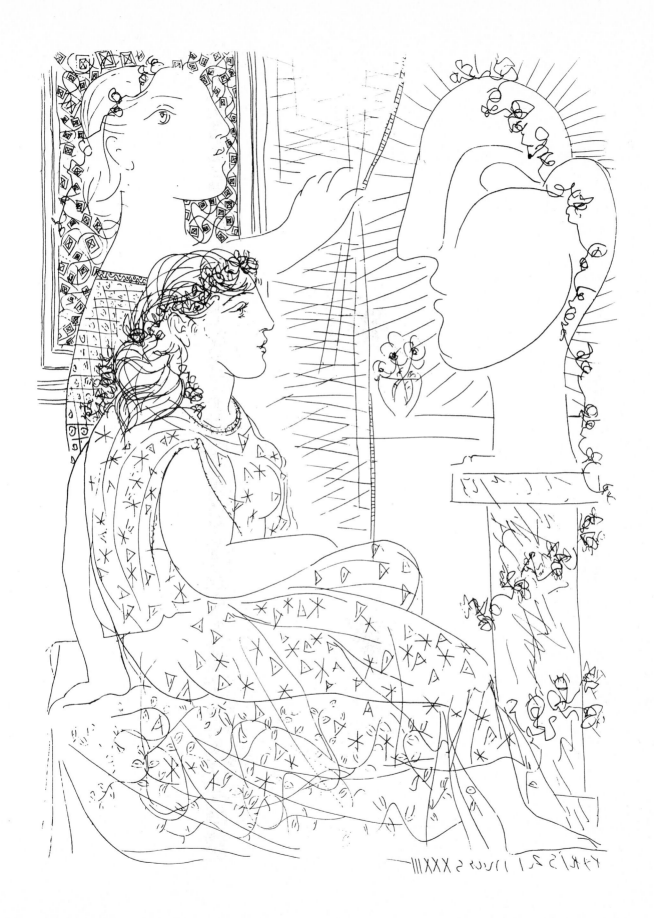

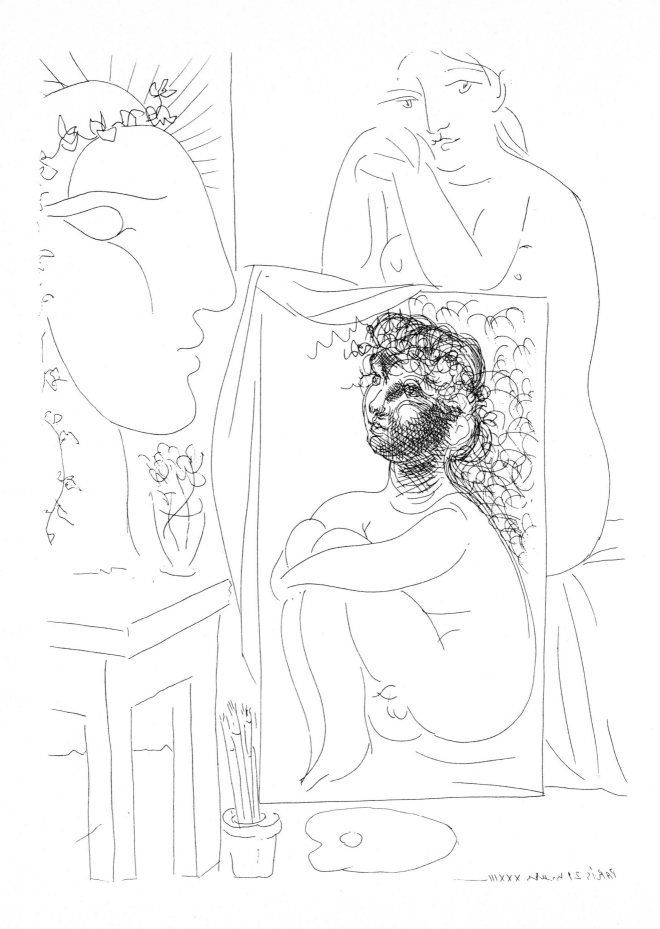

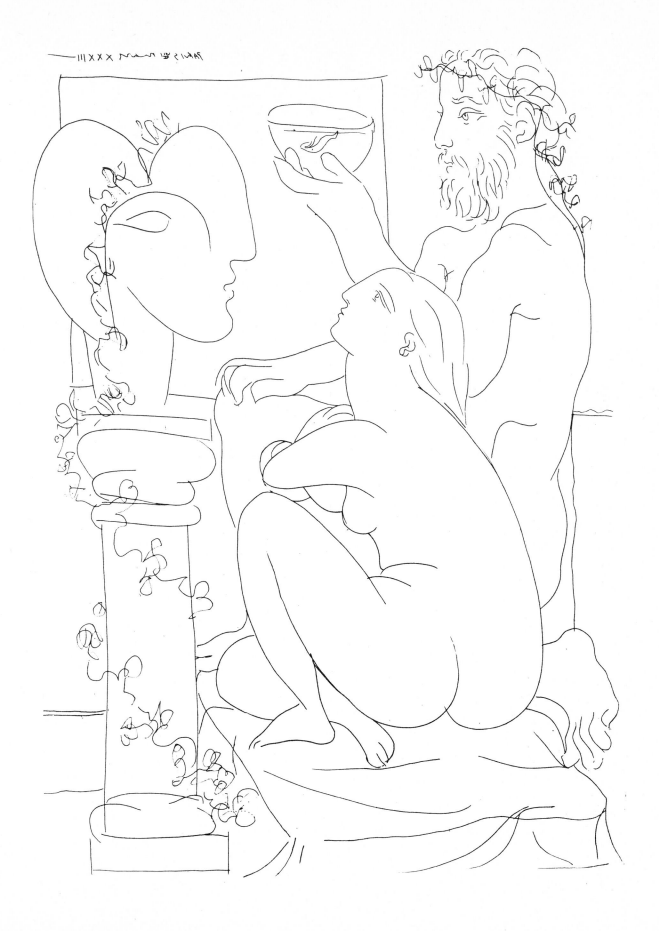

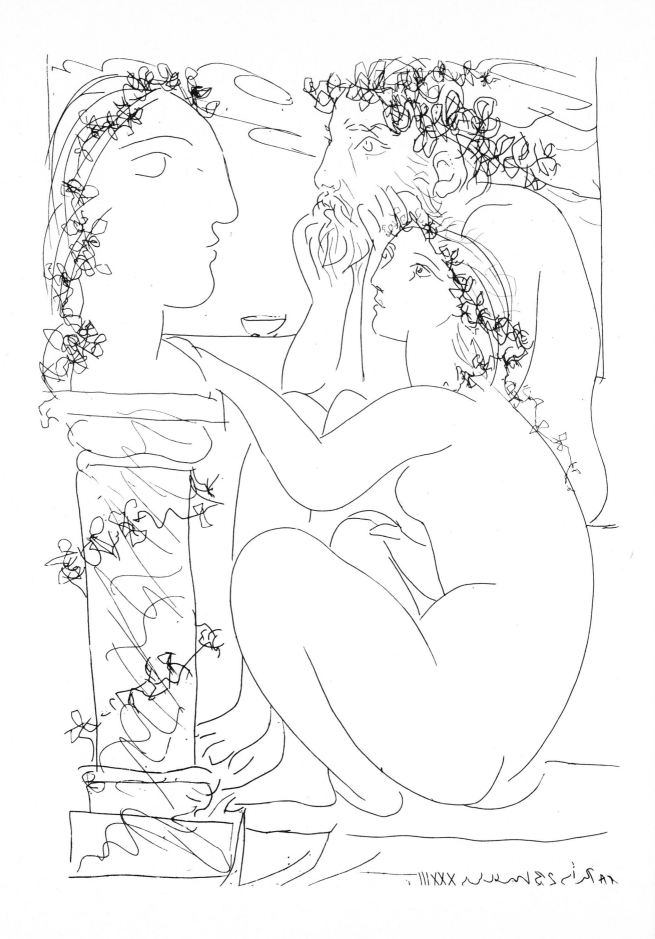

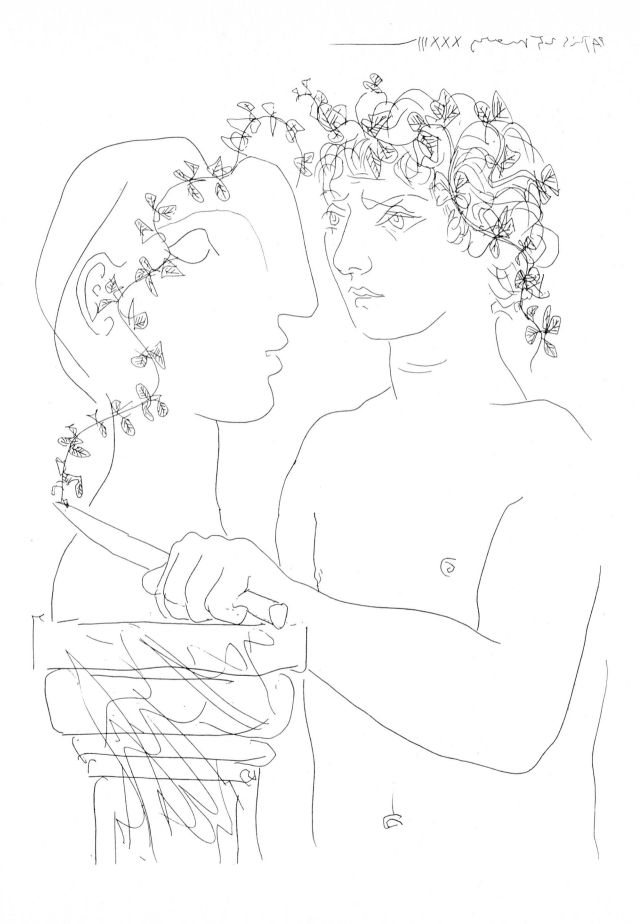

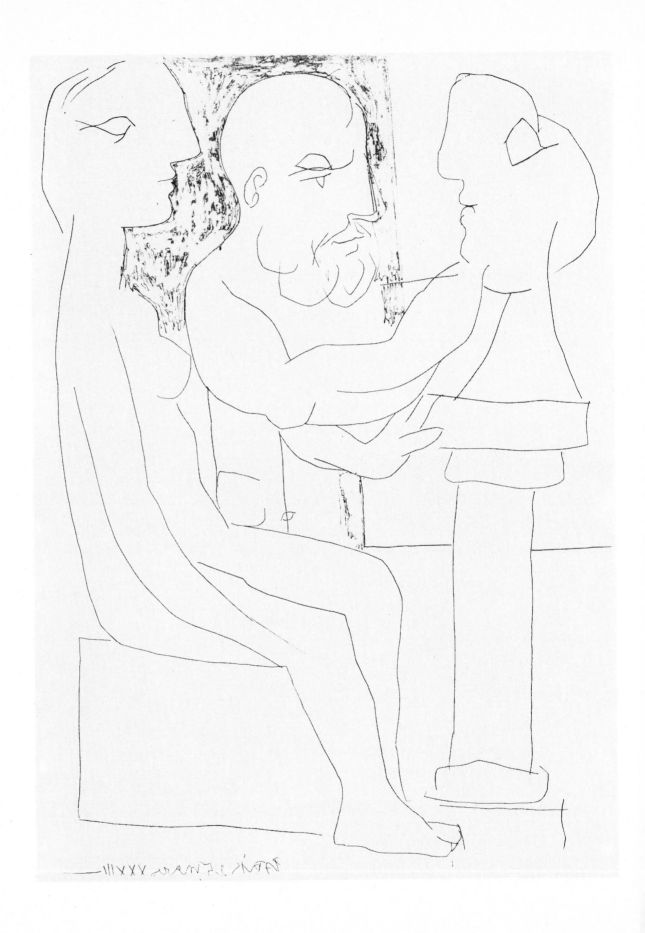

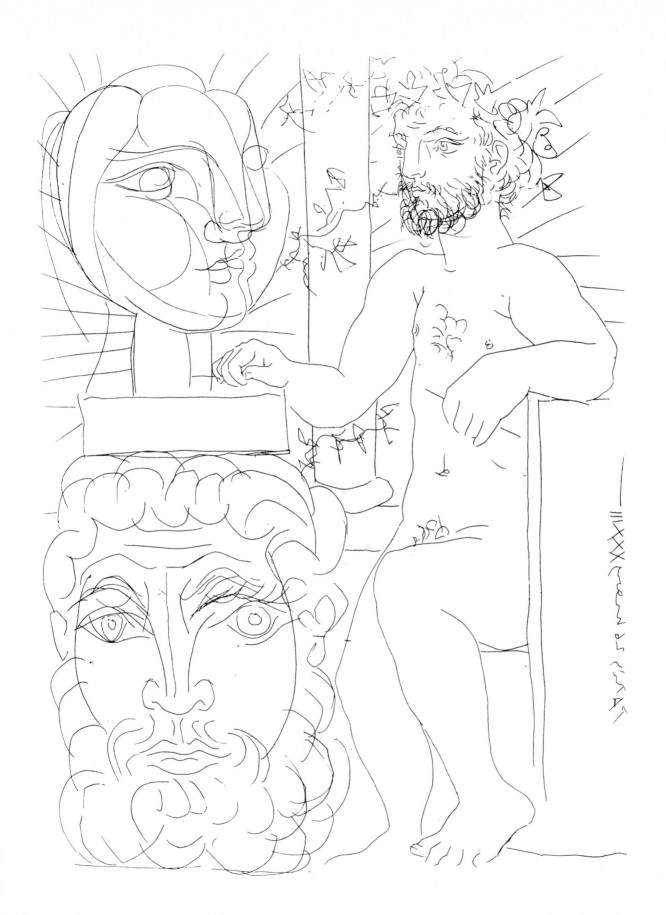

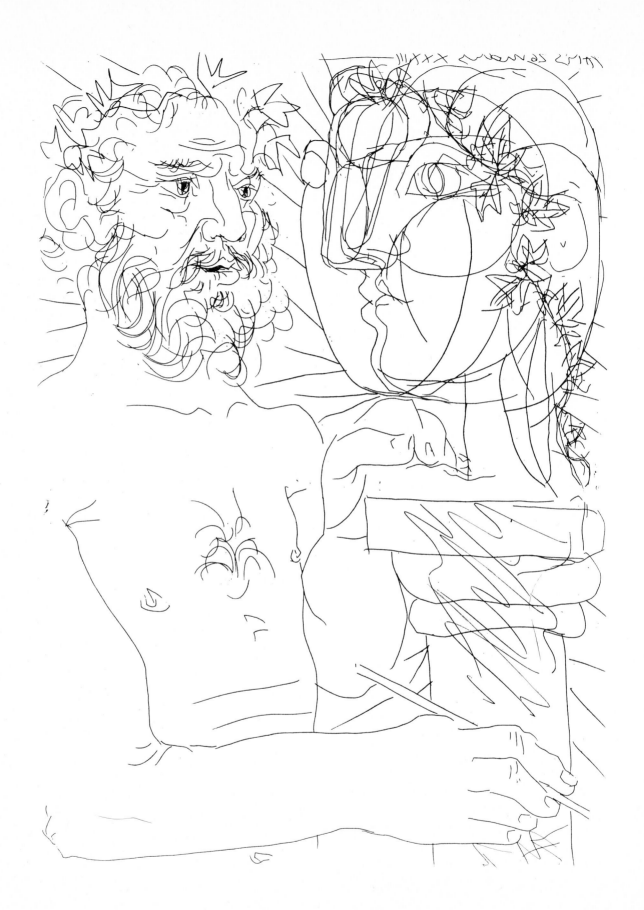

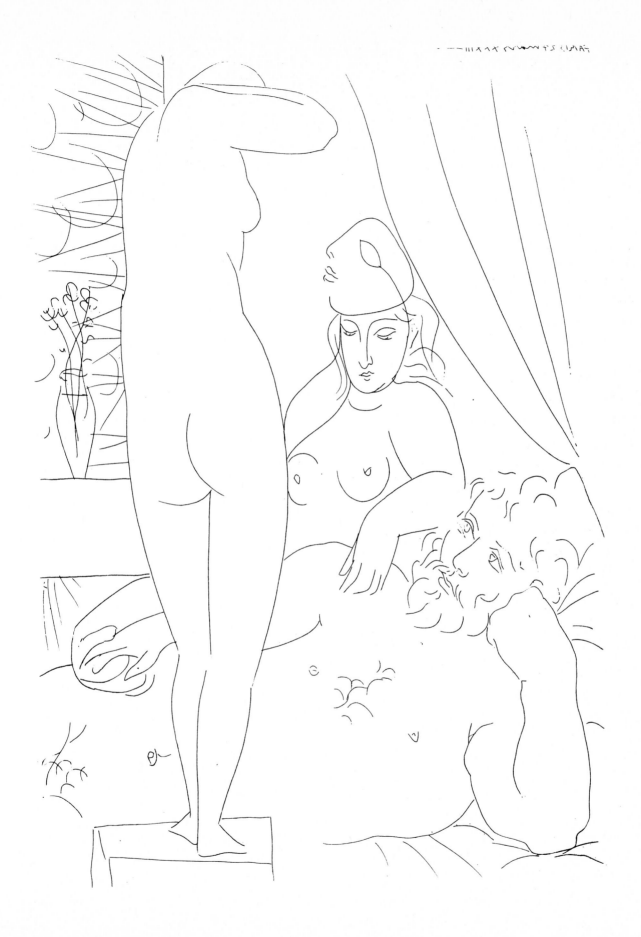

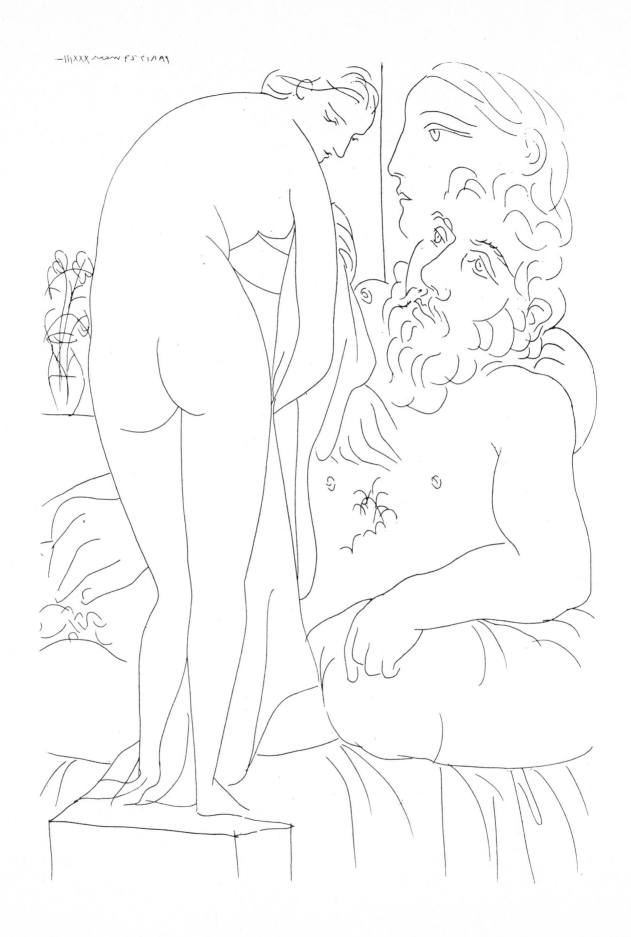

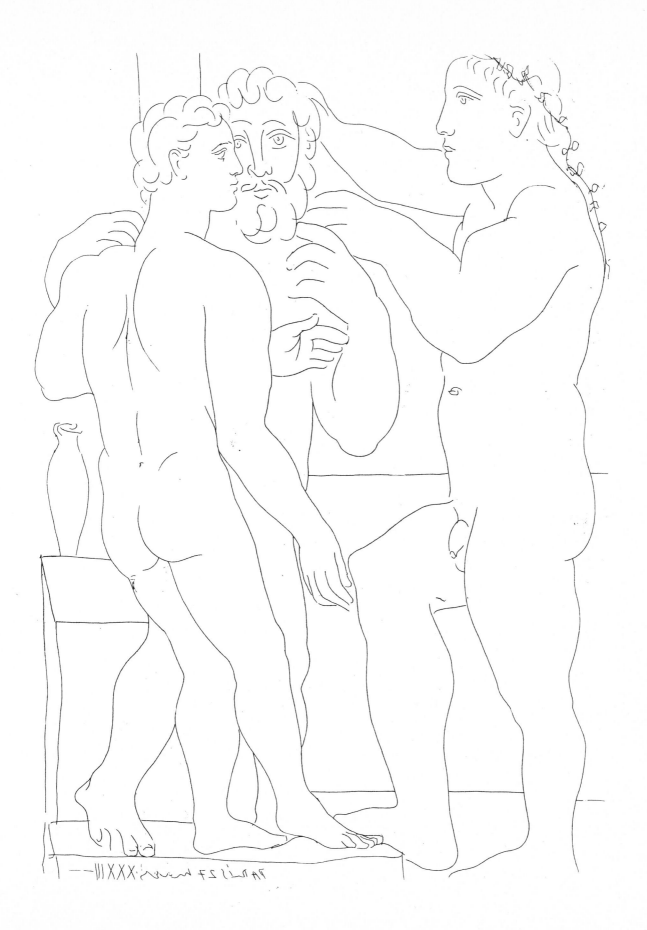

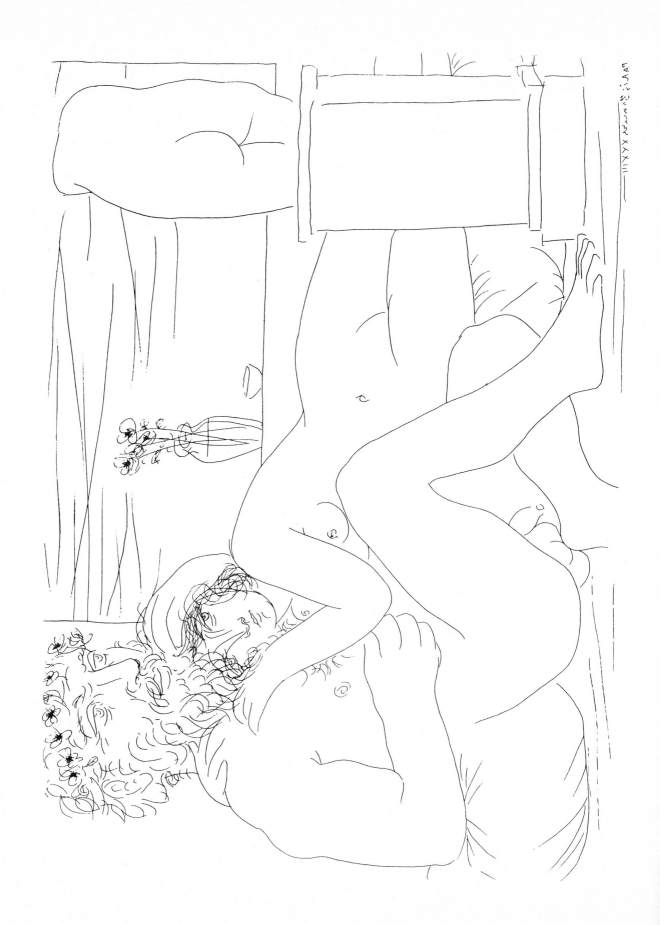

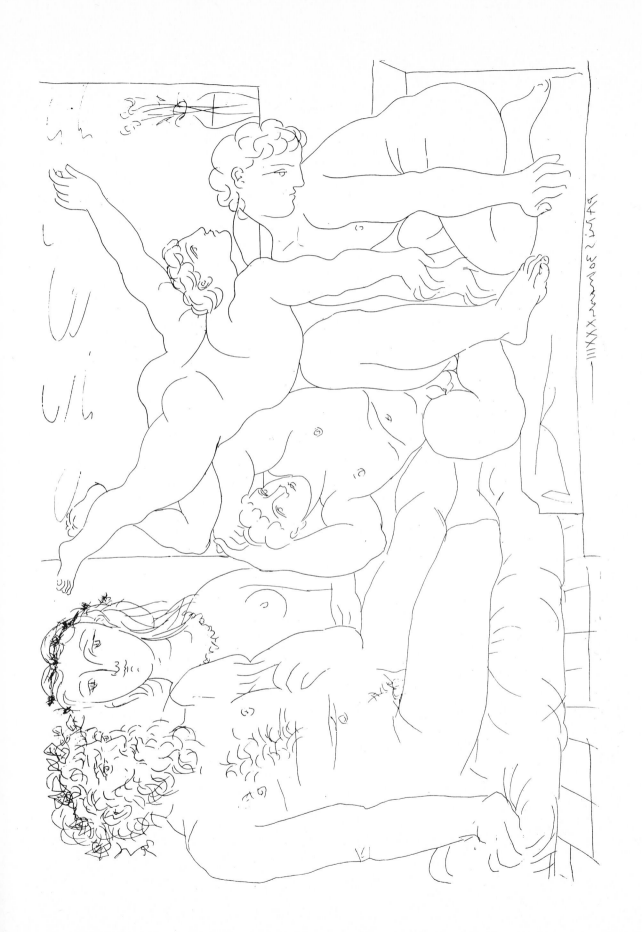

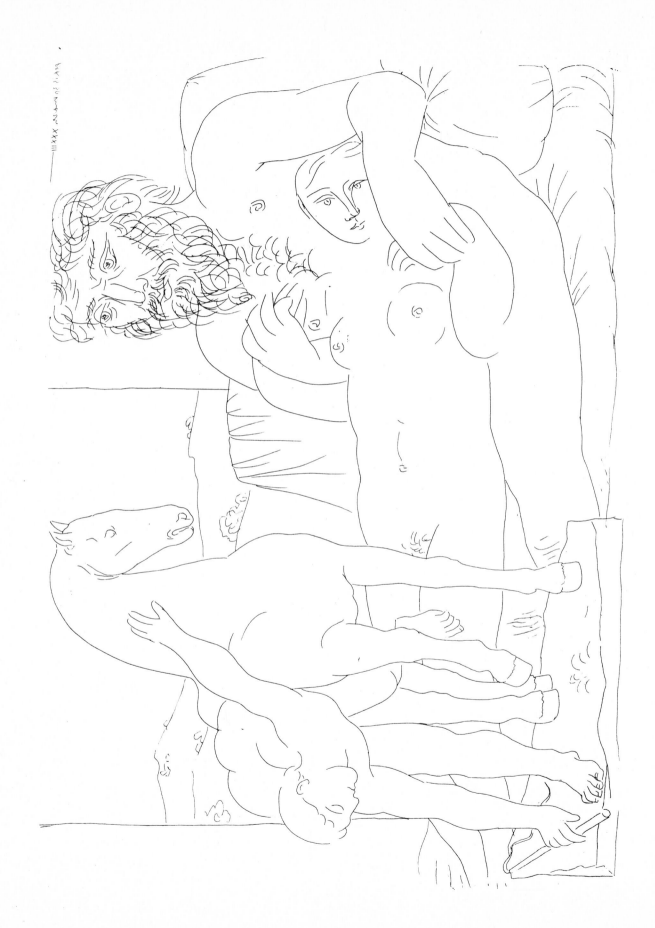

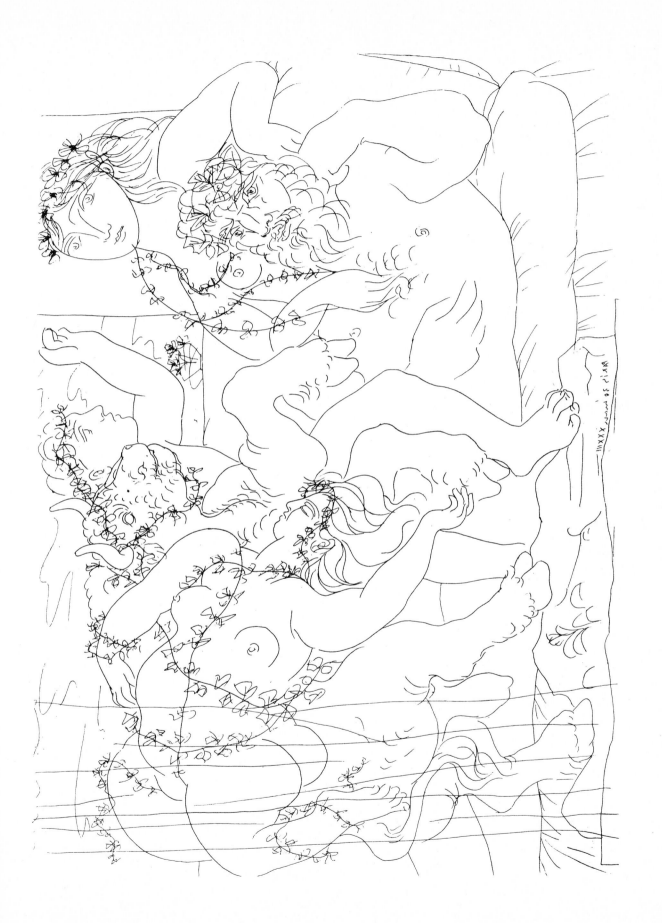

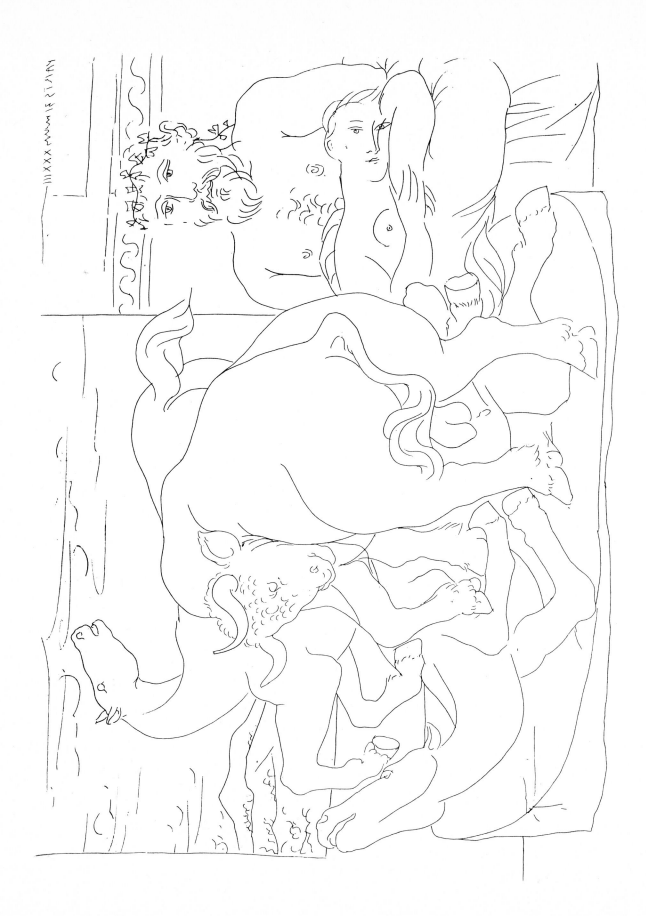

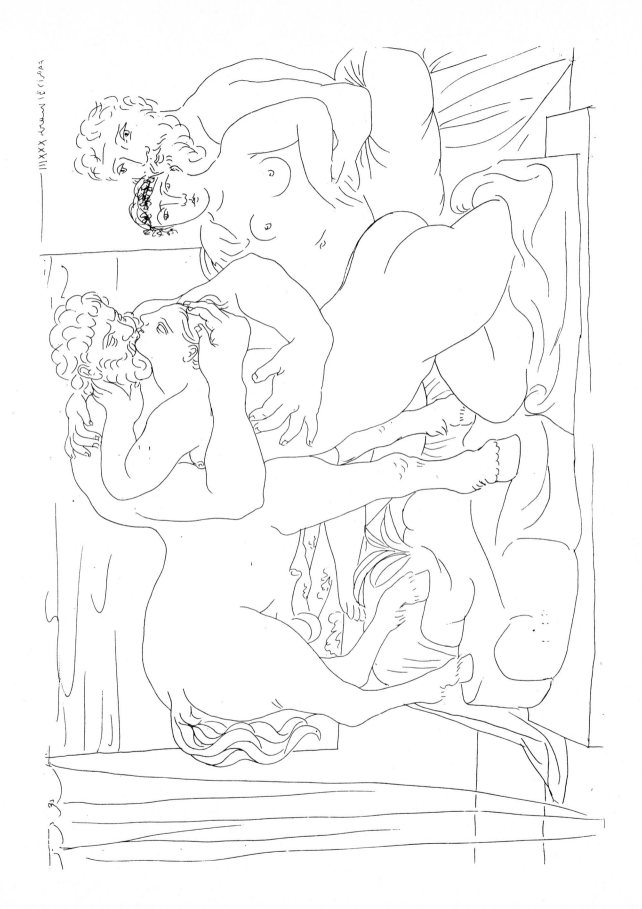

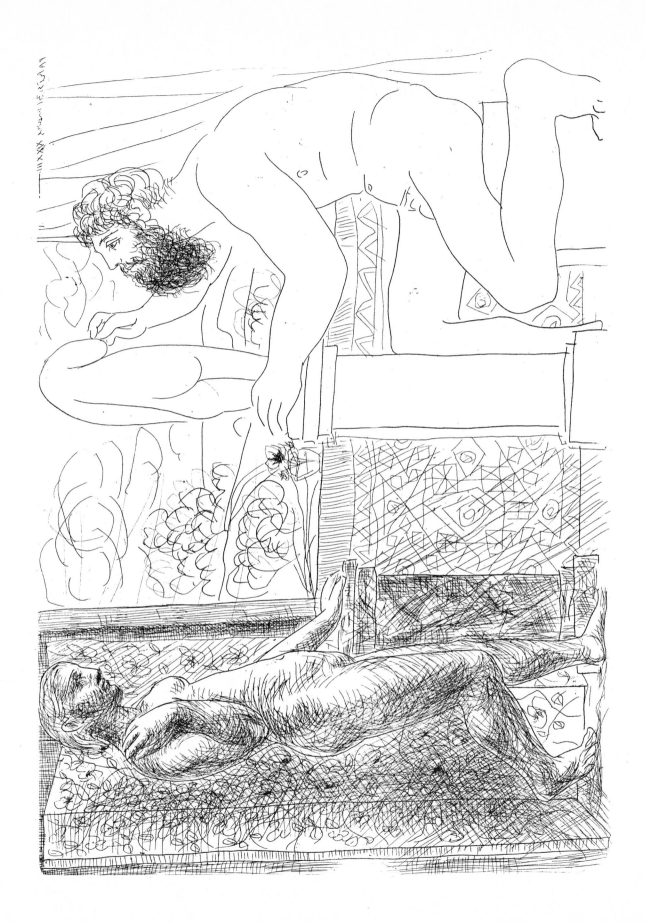

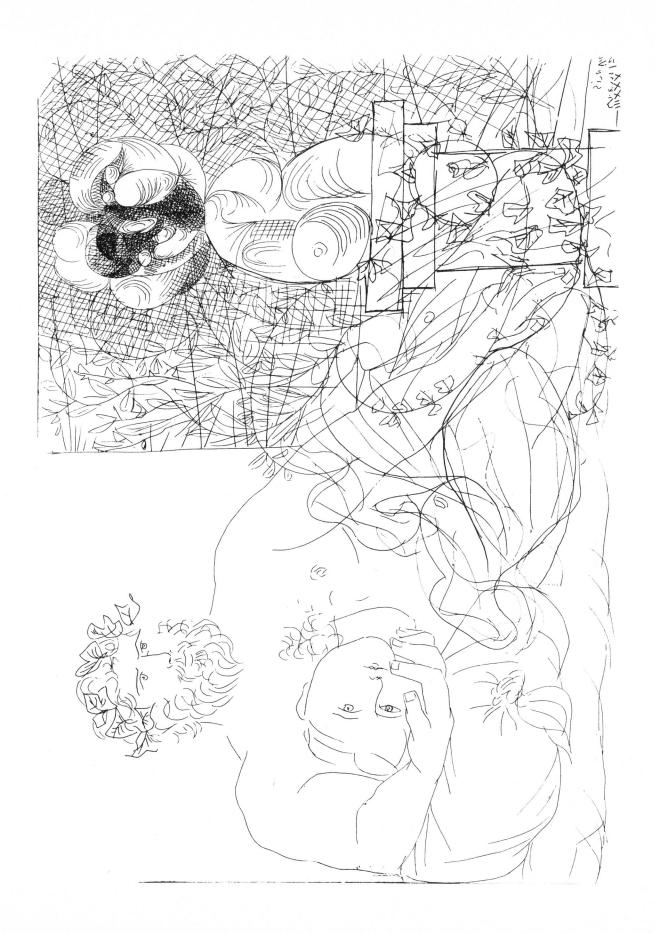

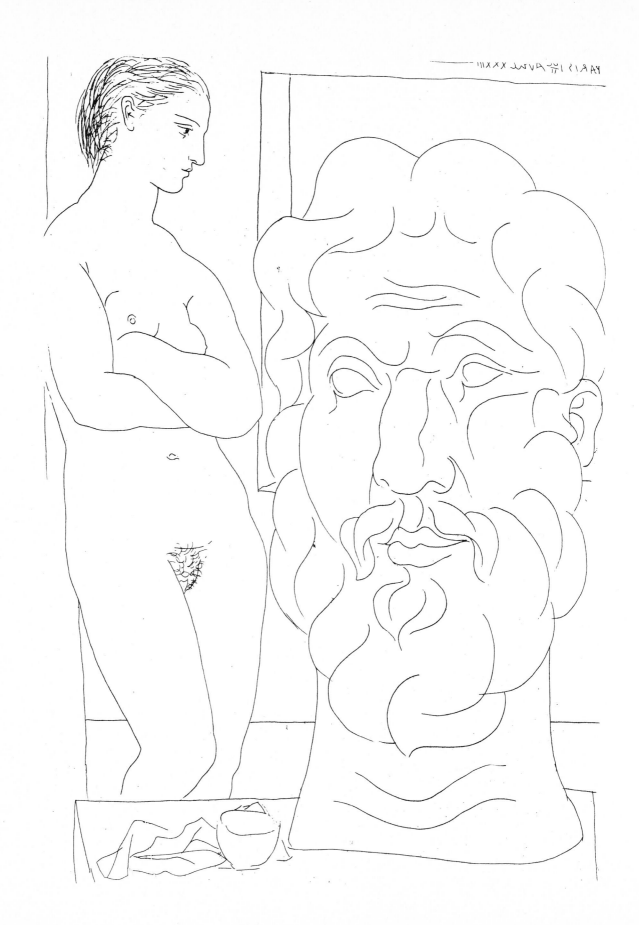
PARIS 1ᵉʳ AVRIL XXXIII

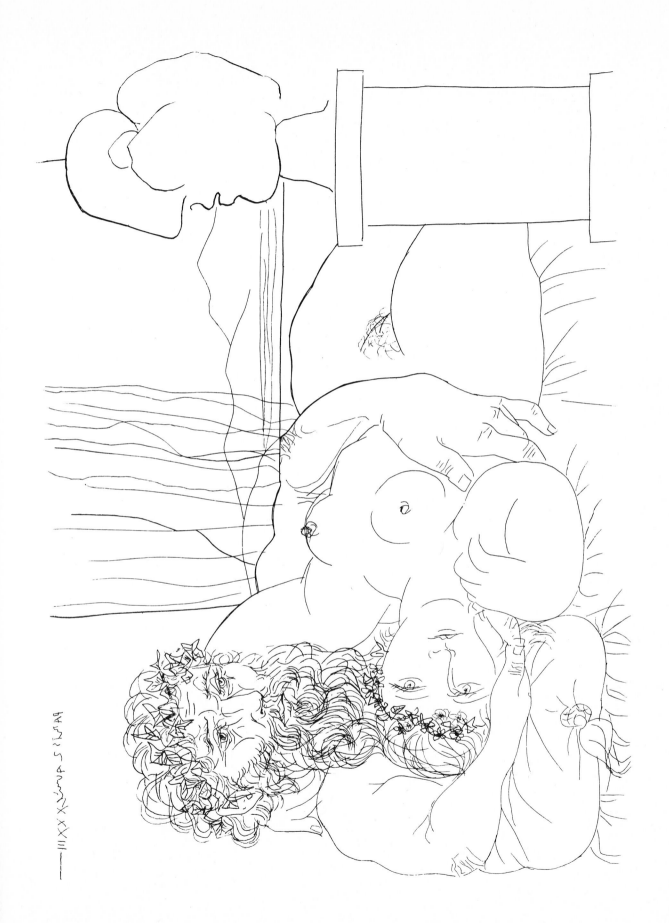

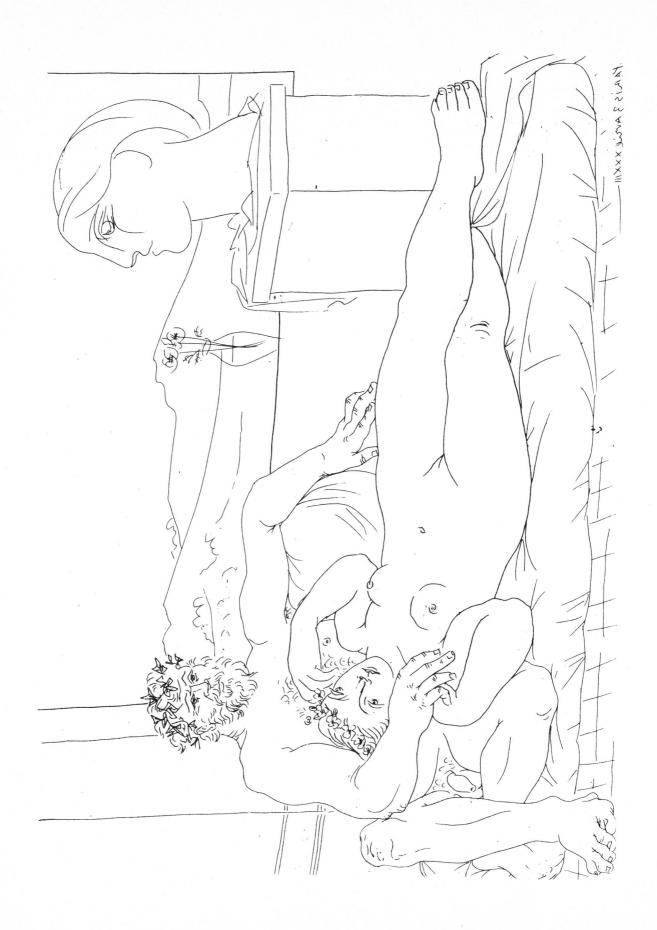

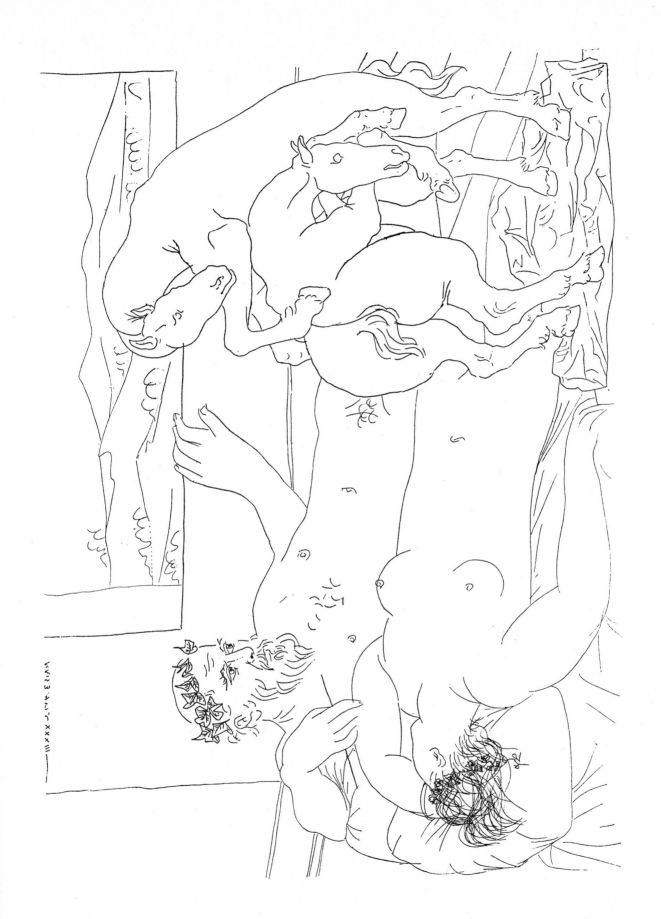

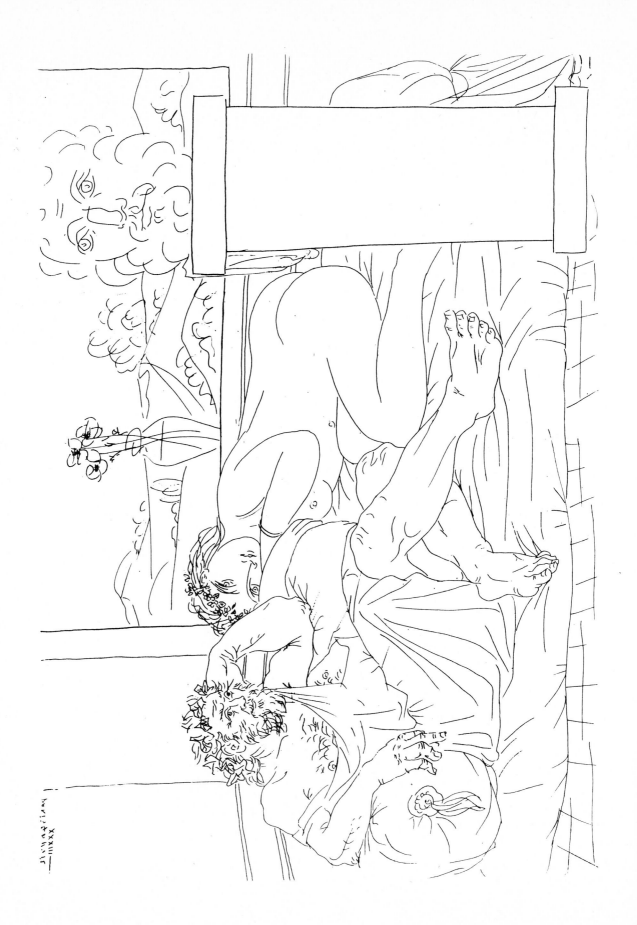

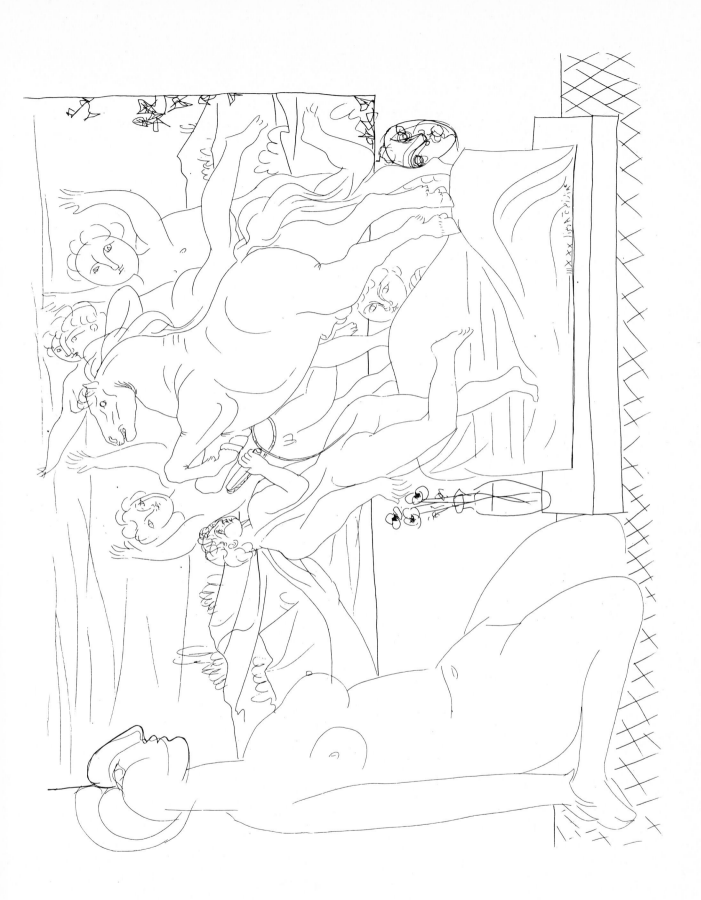

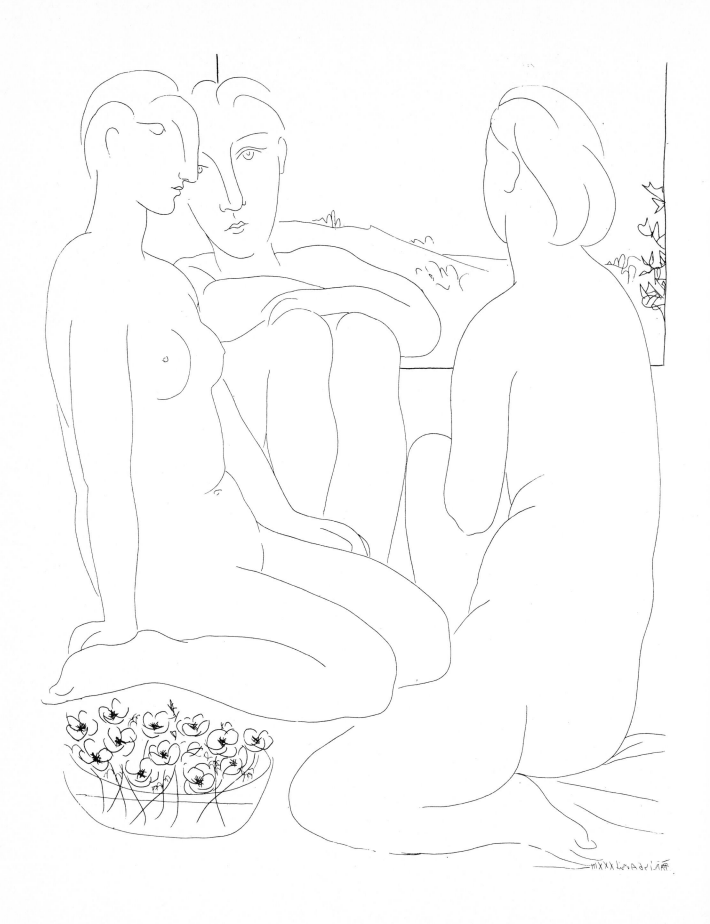

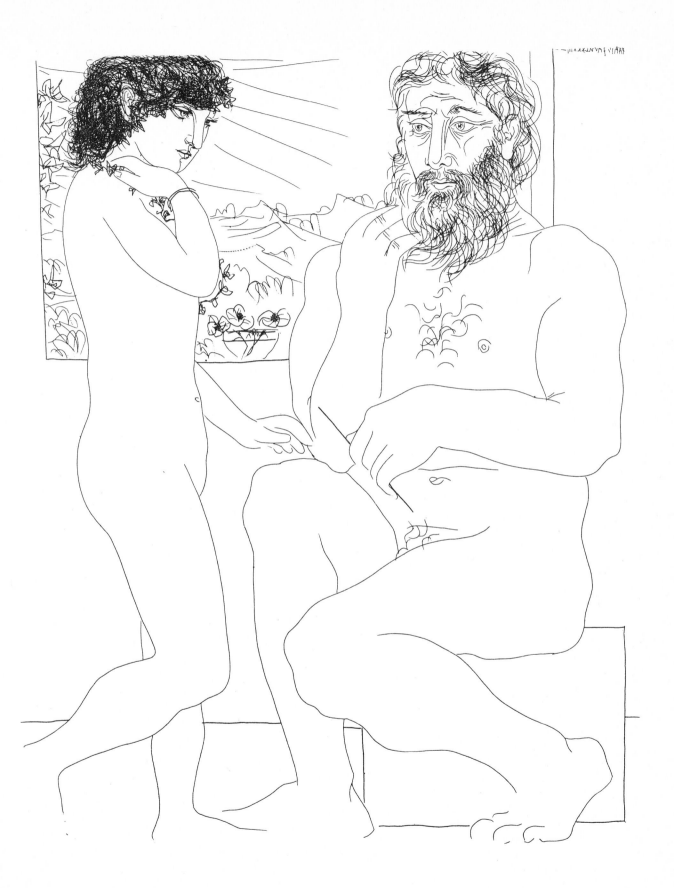

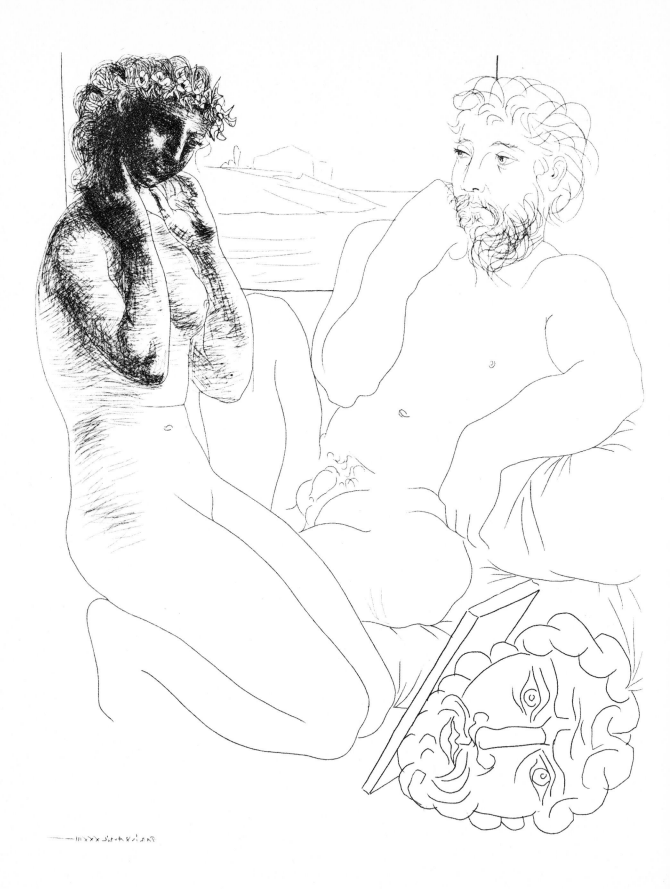

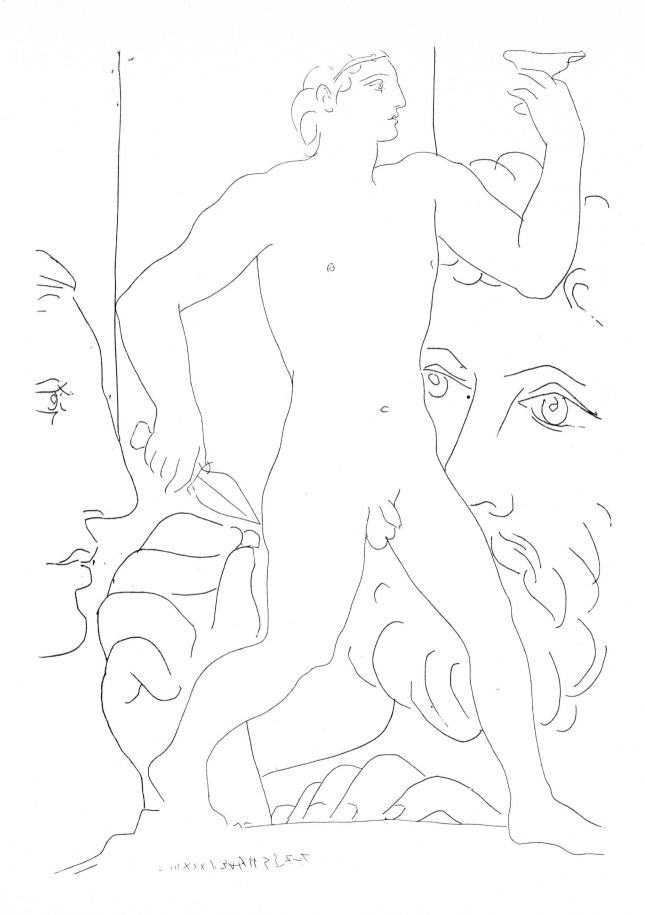

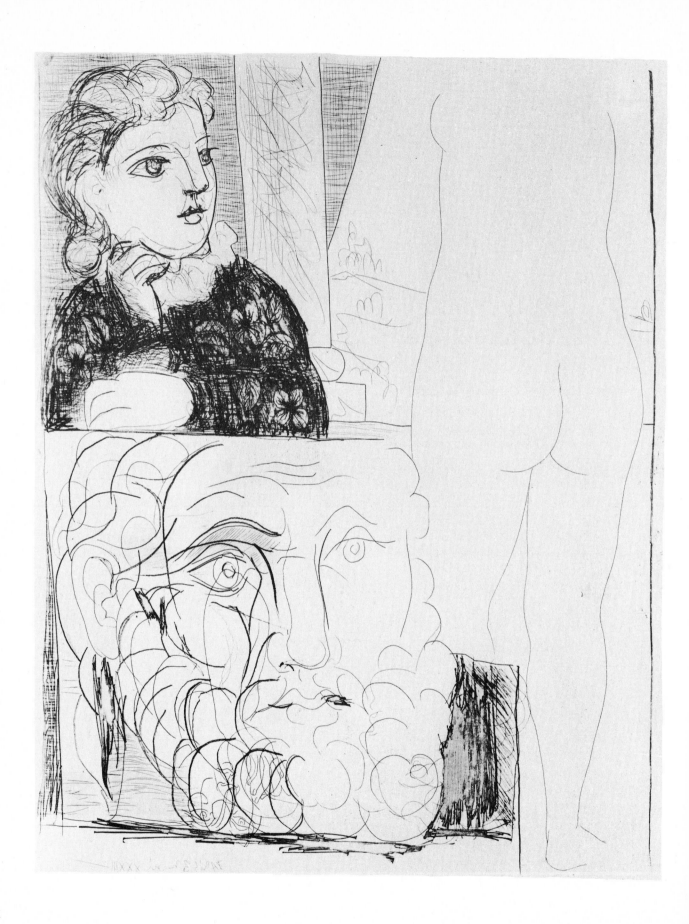

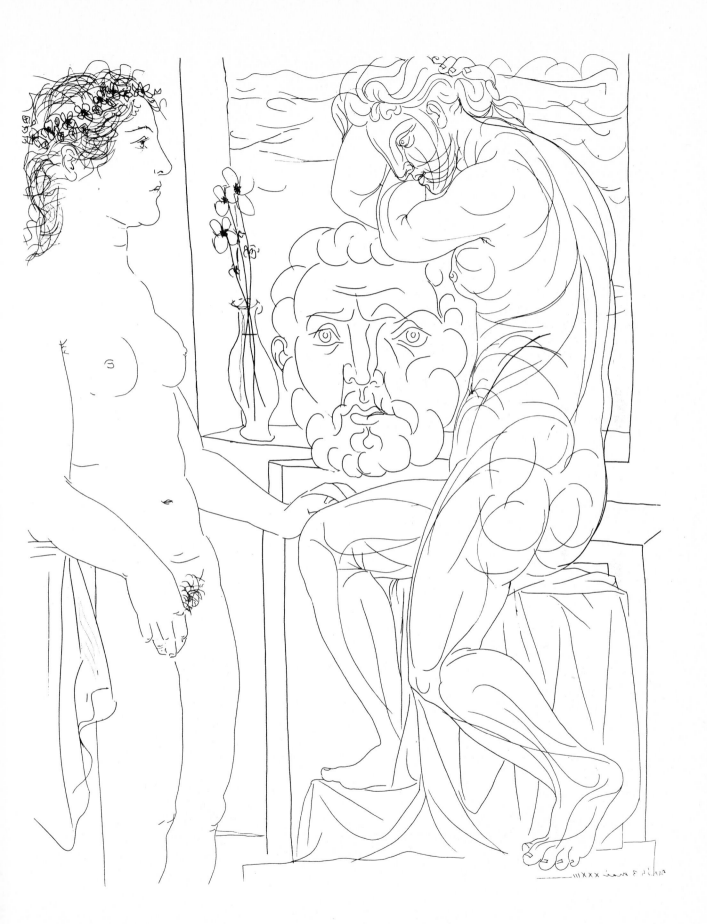

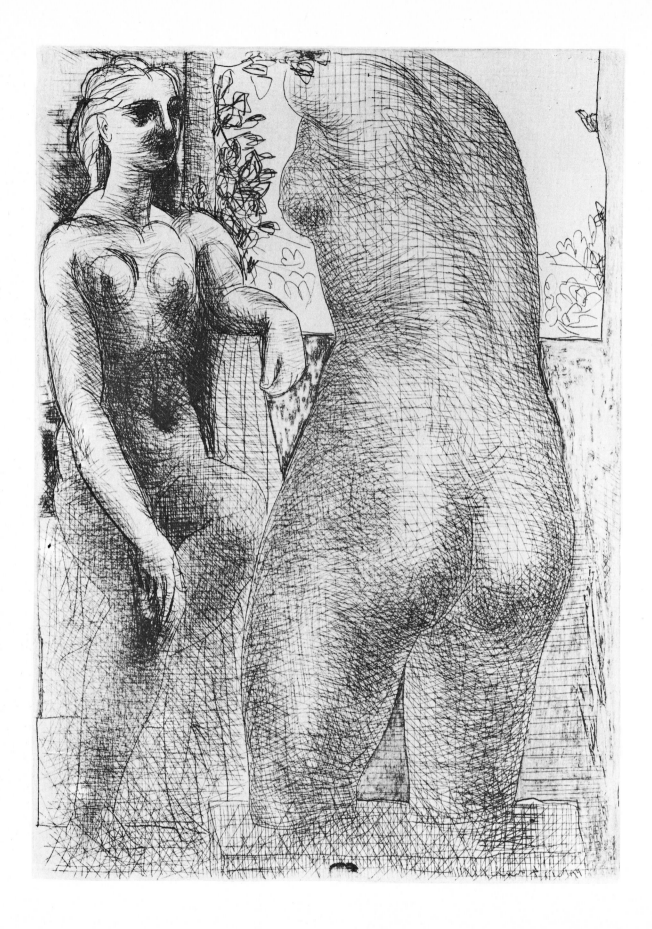

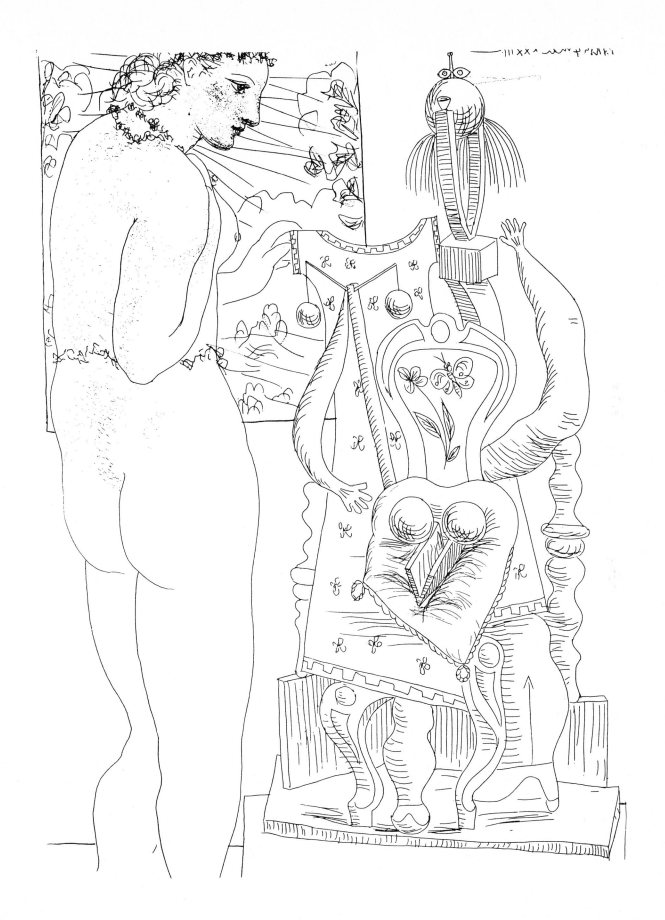

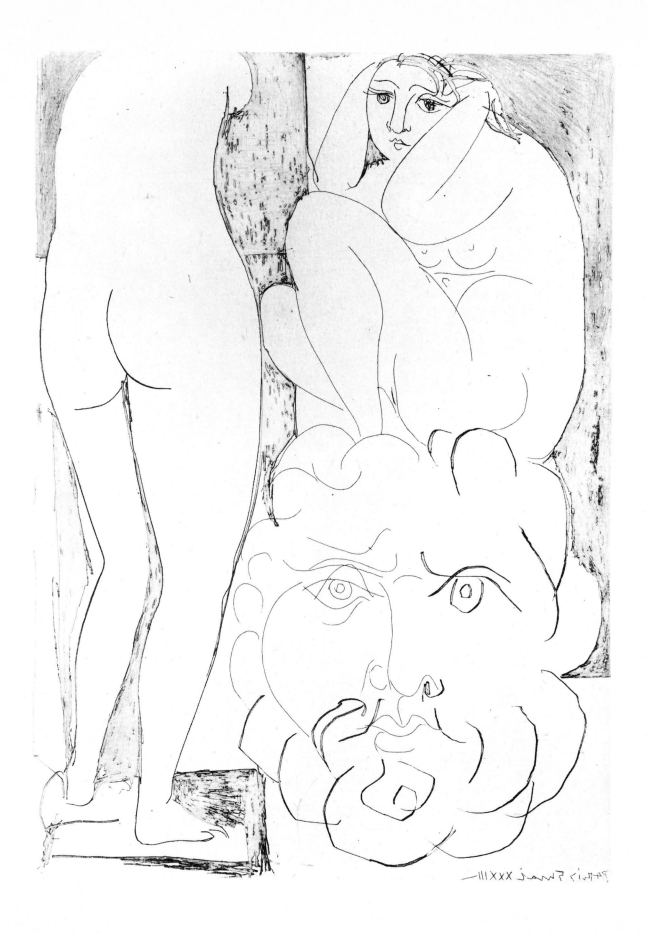

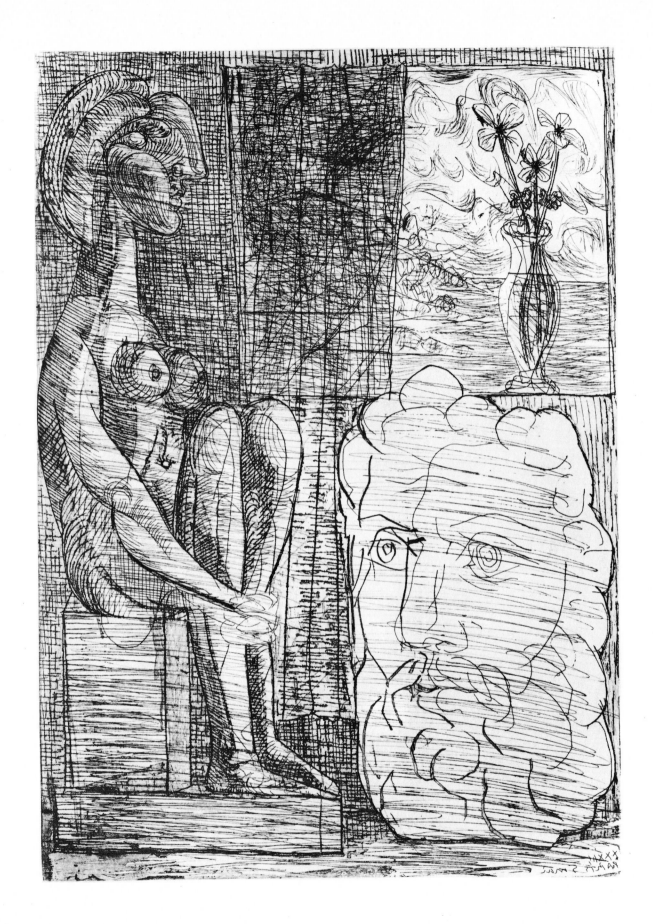

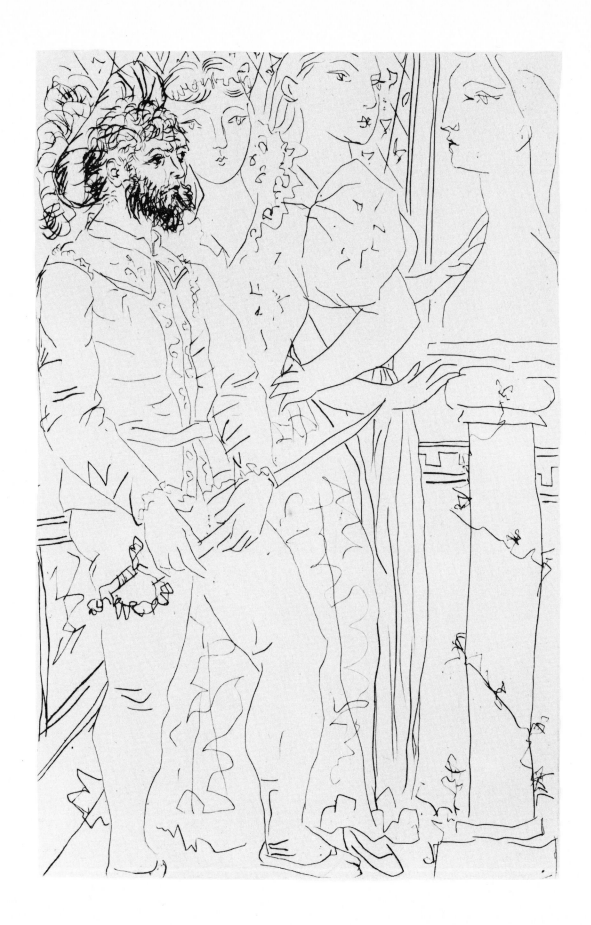

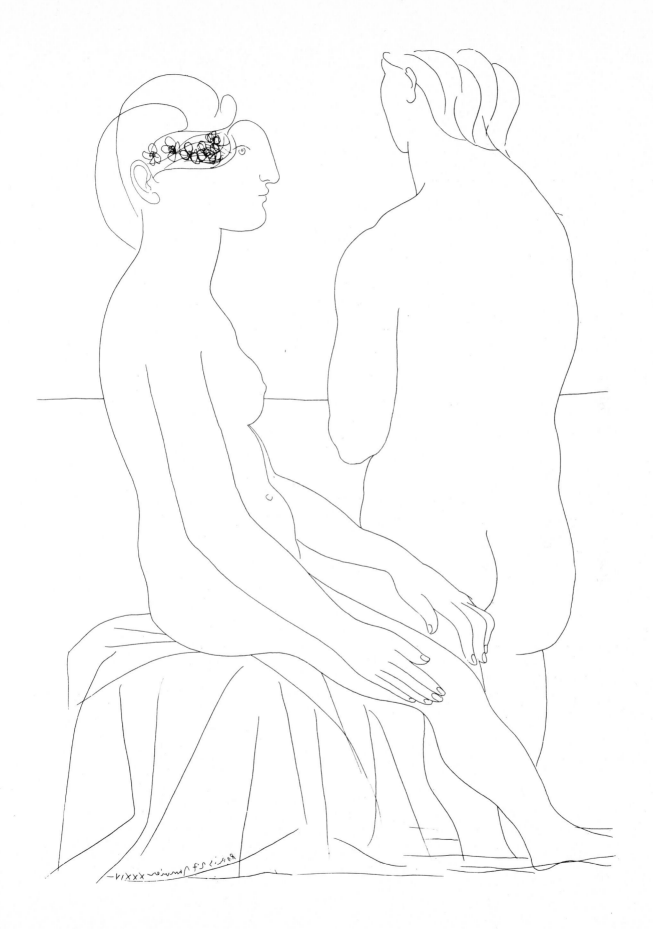

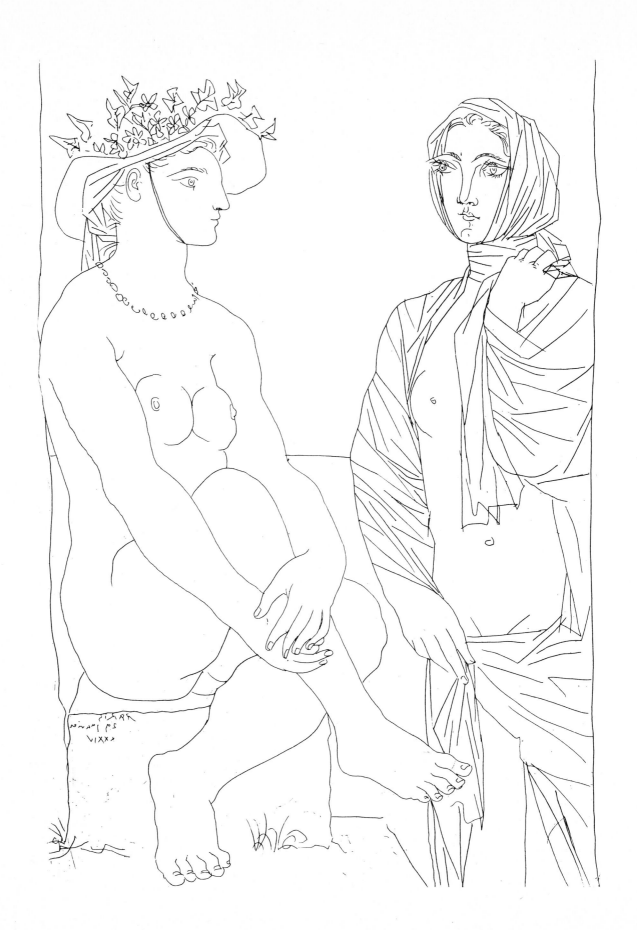

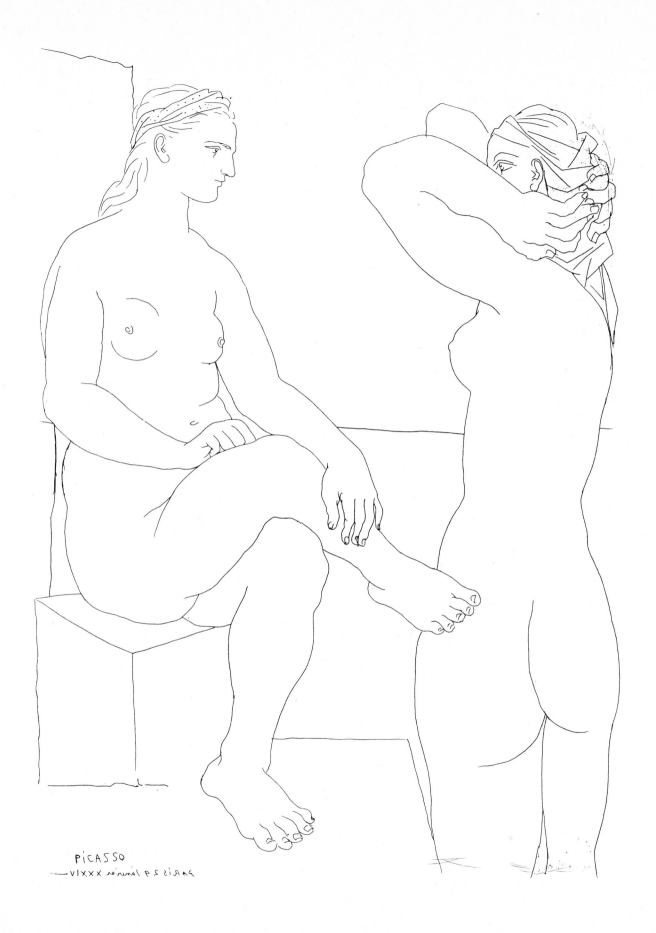

PICASSO
PARIS 29 Janvier XXXIV

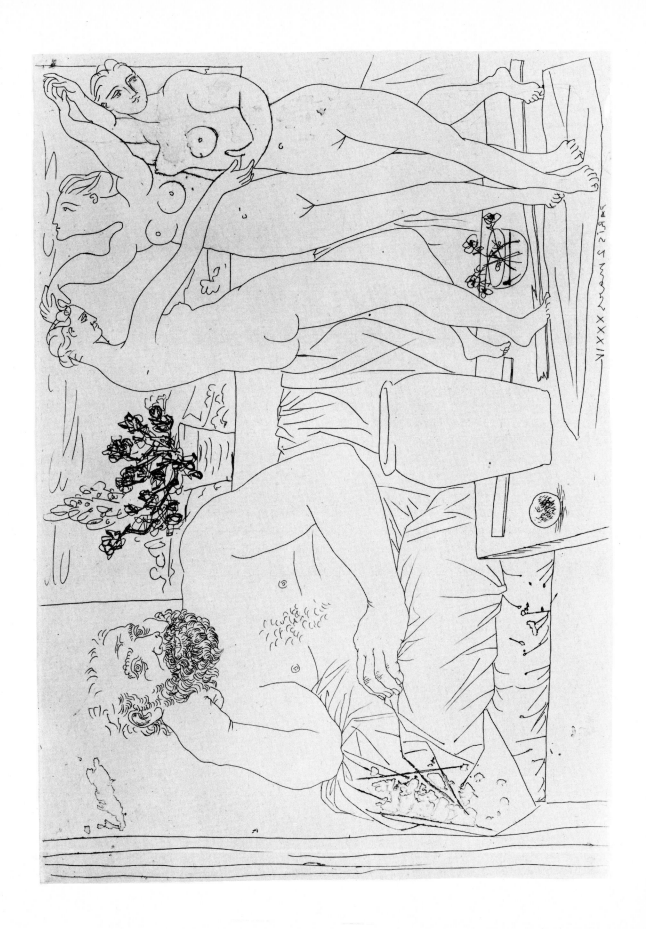

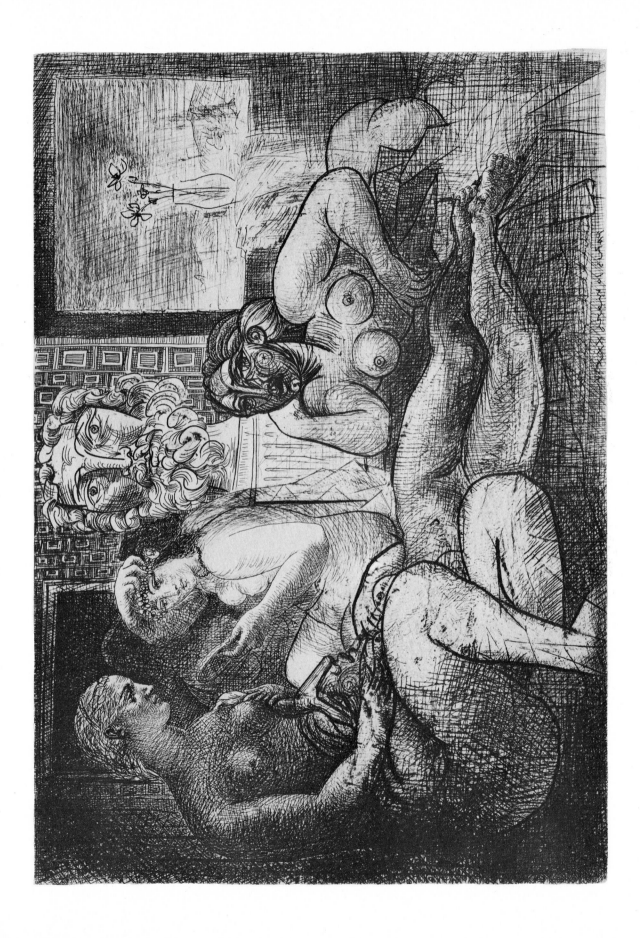

THE MINOTAUR

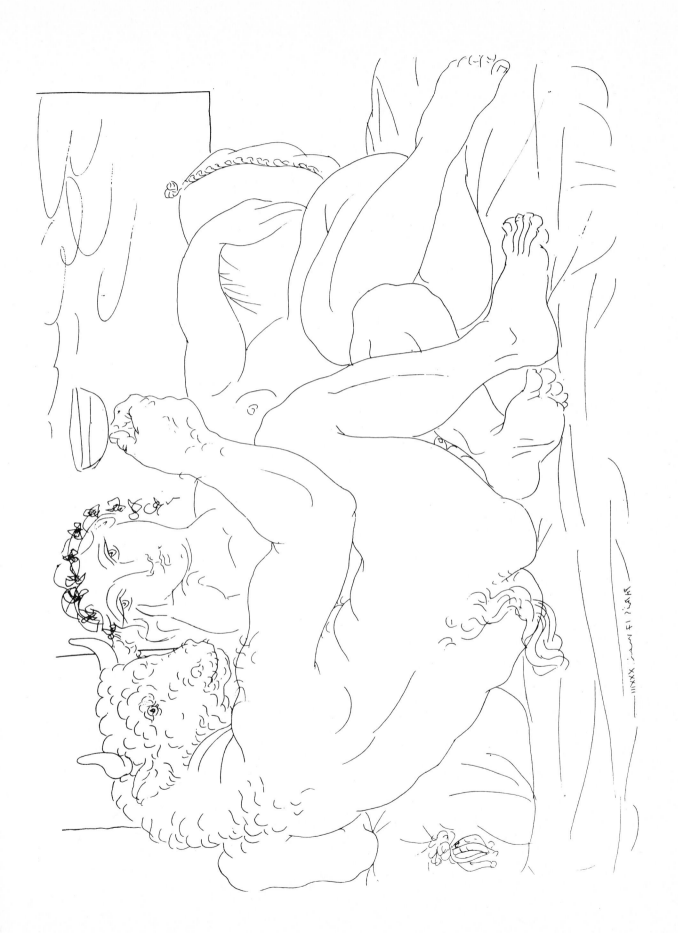

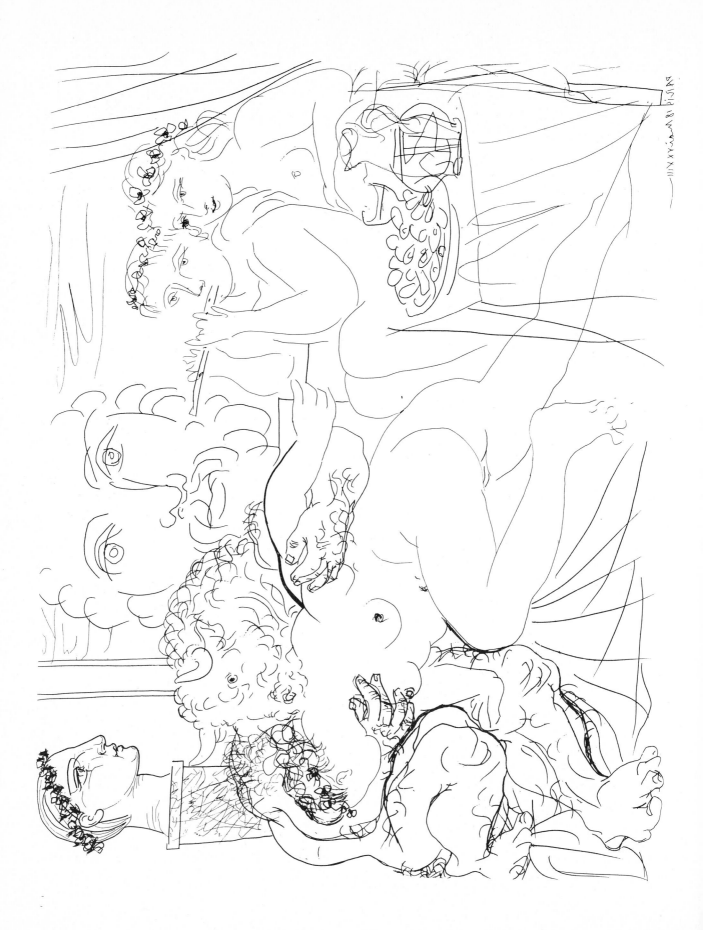

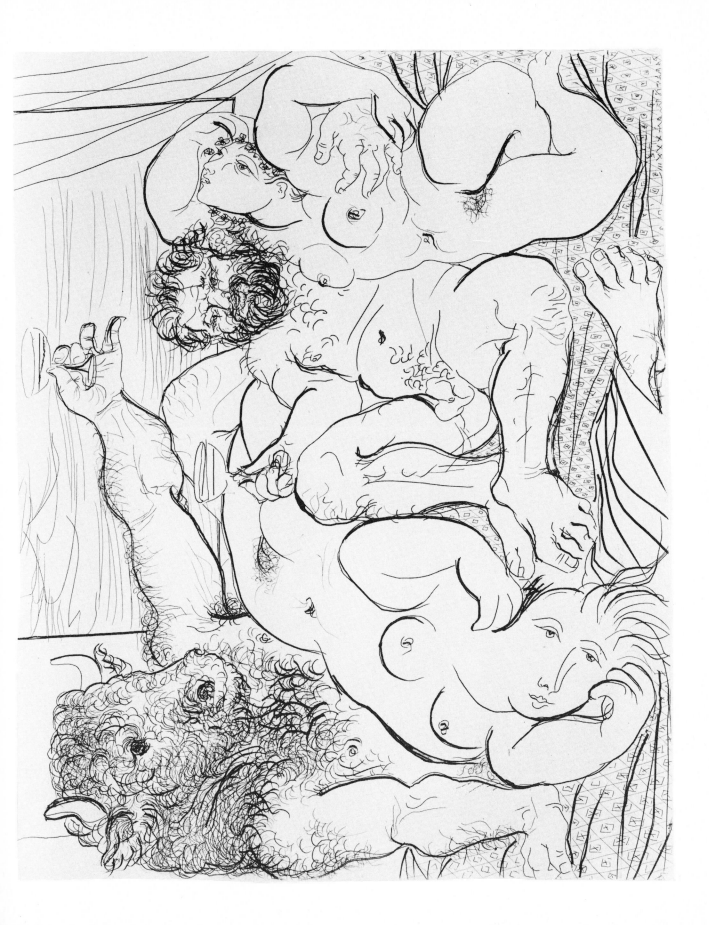

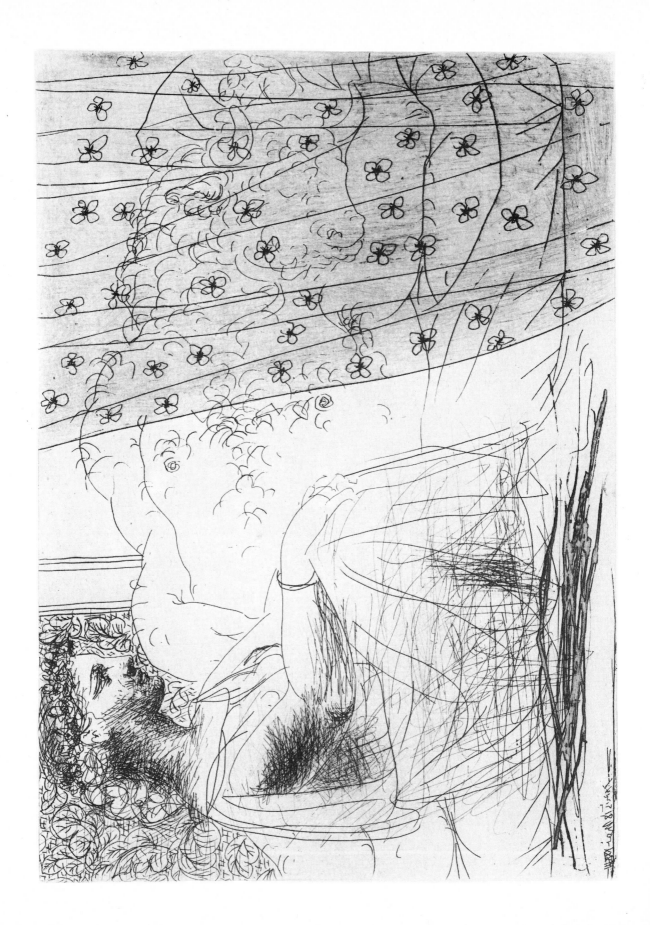

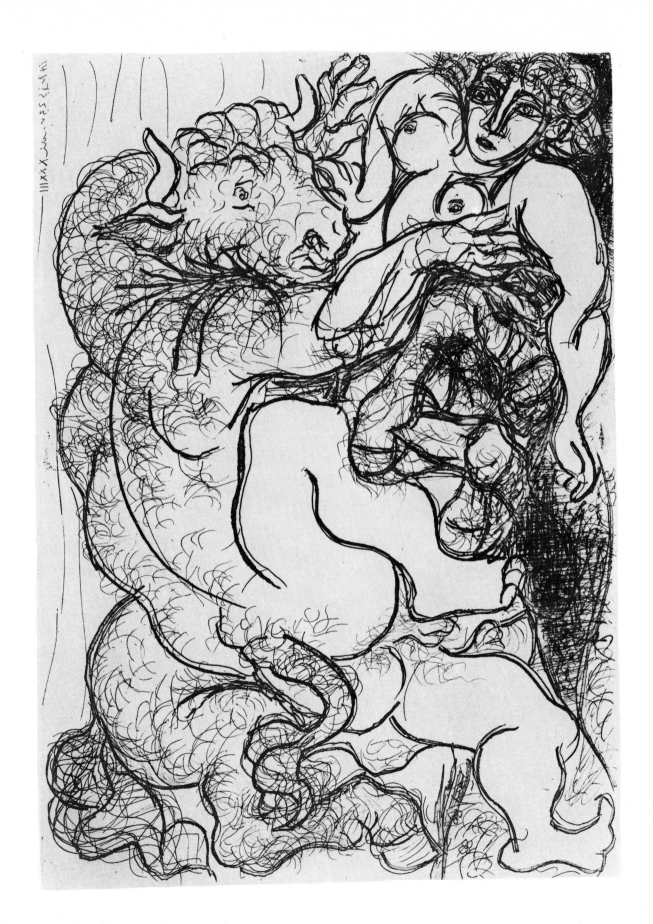

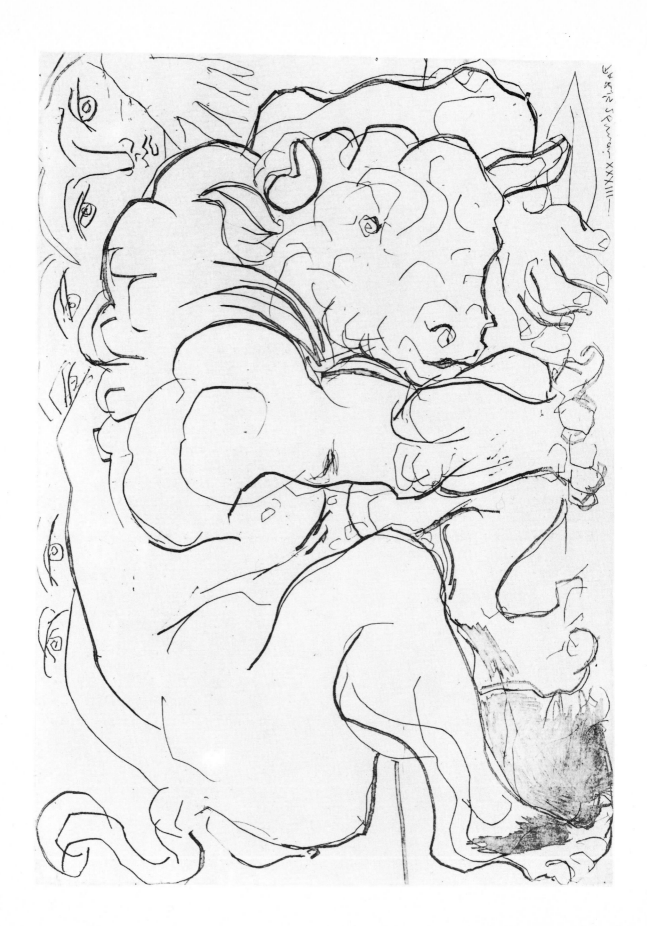

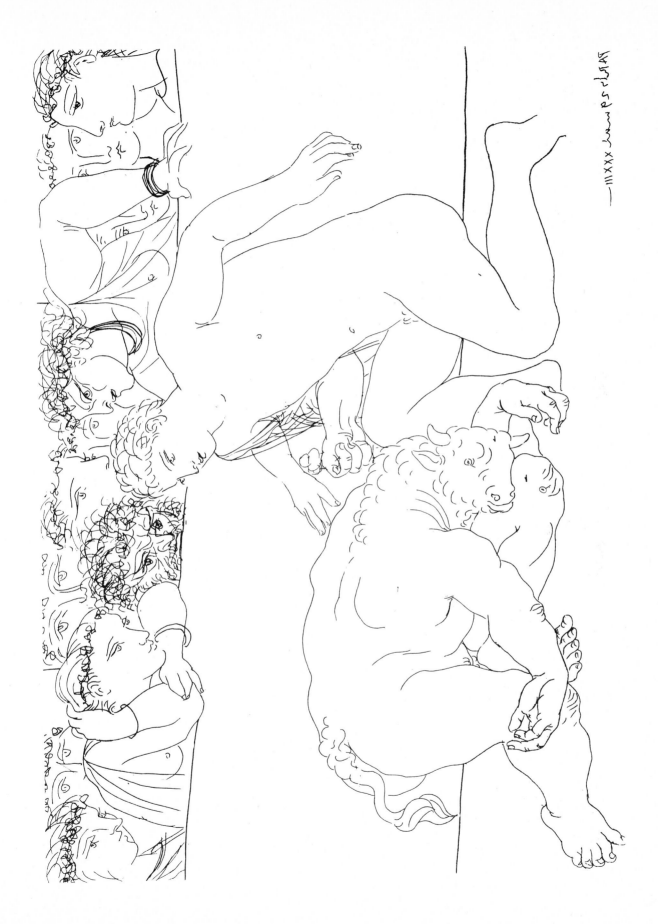

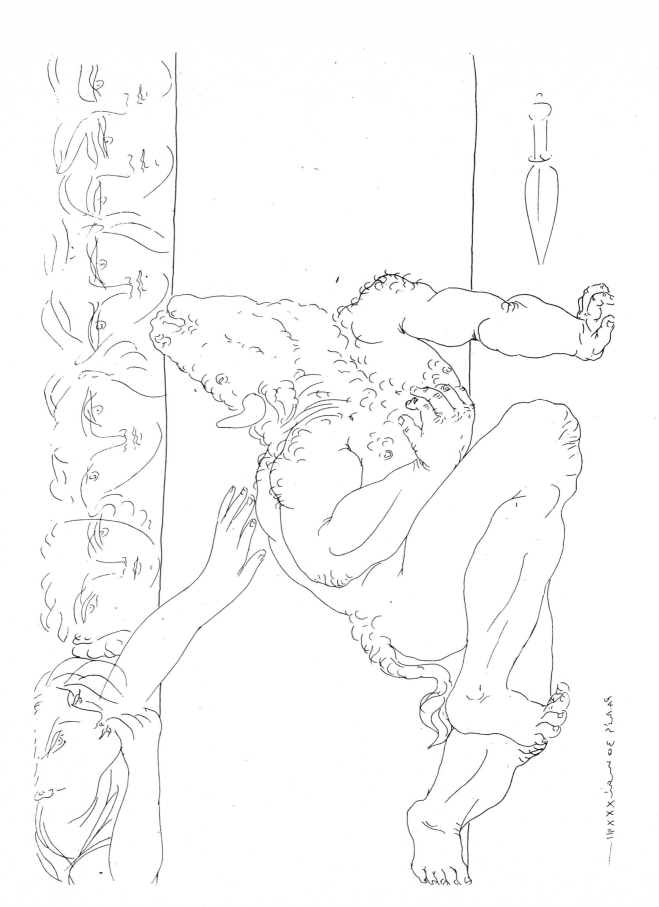

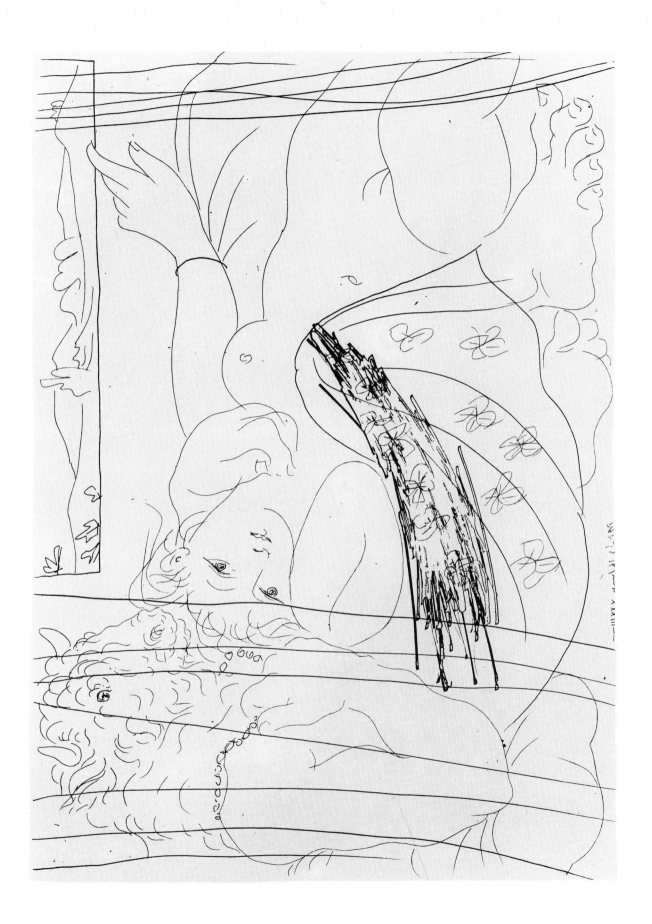

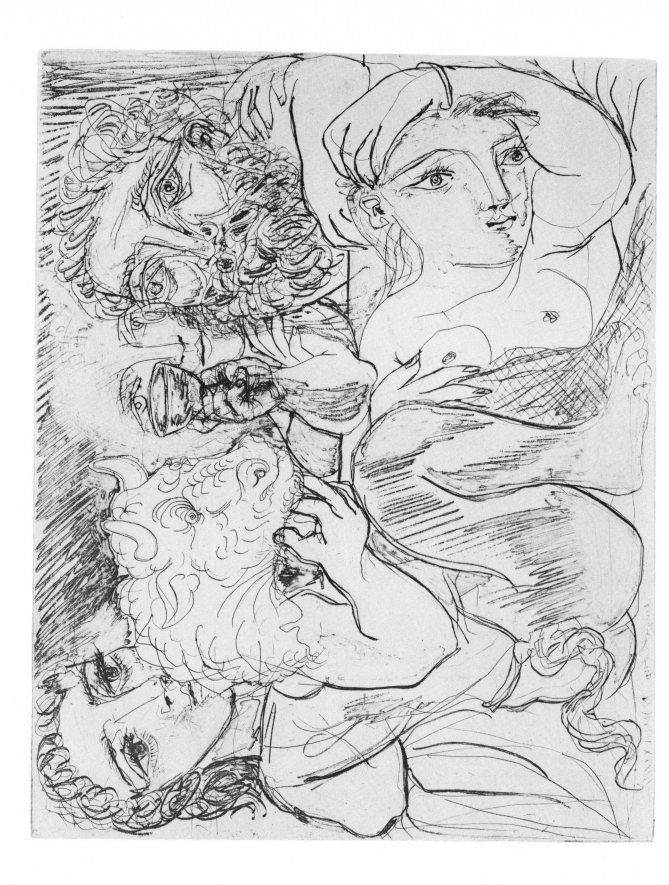

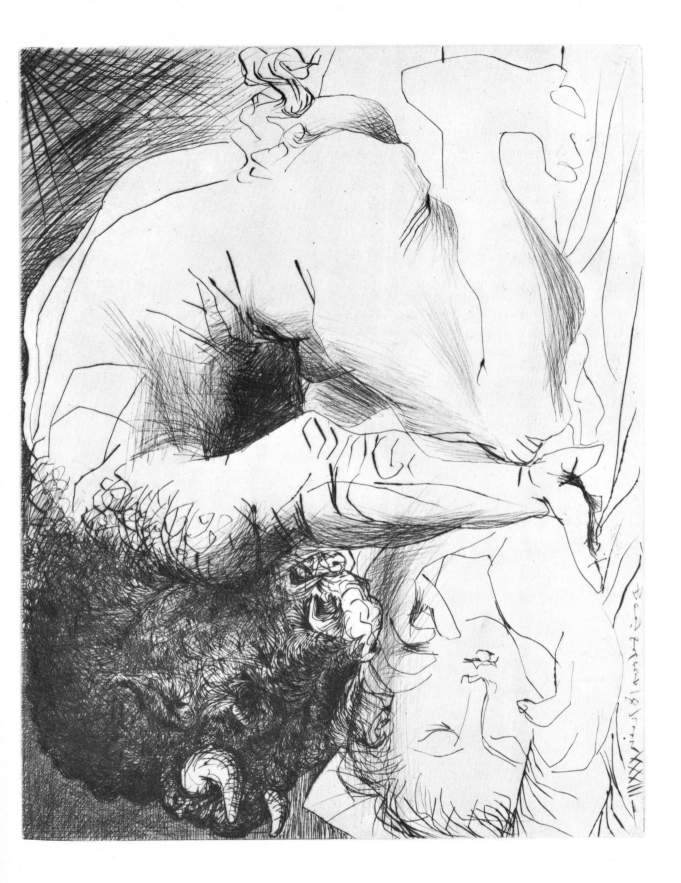

THE BLIND MINOTAUR

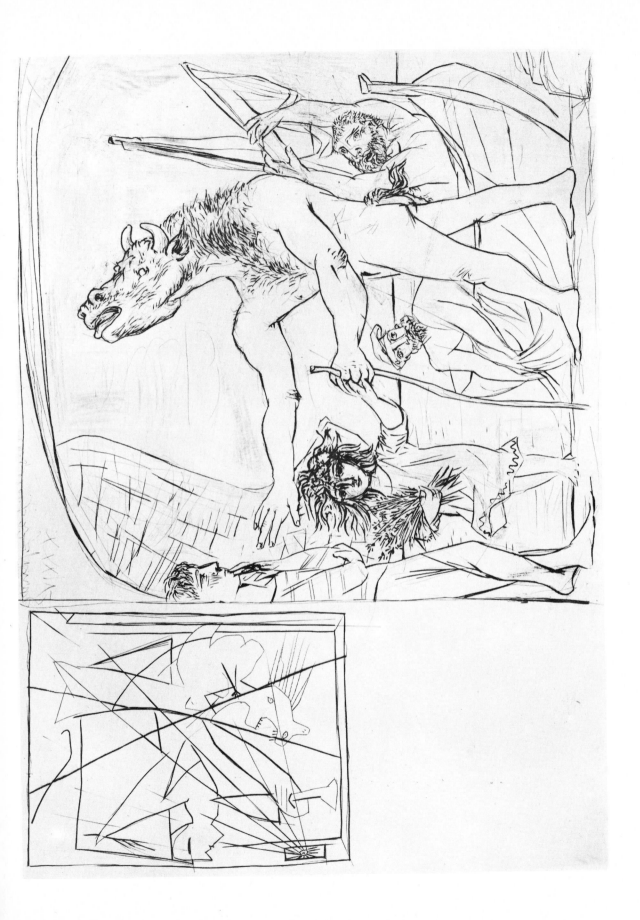

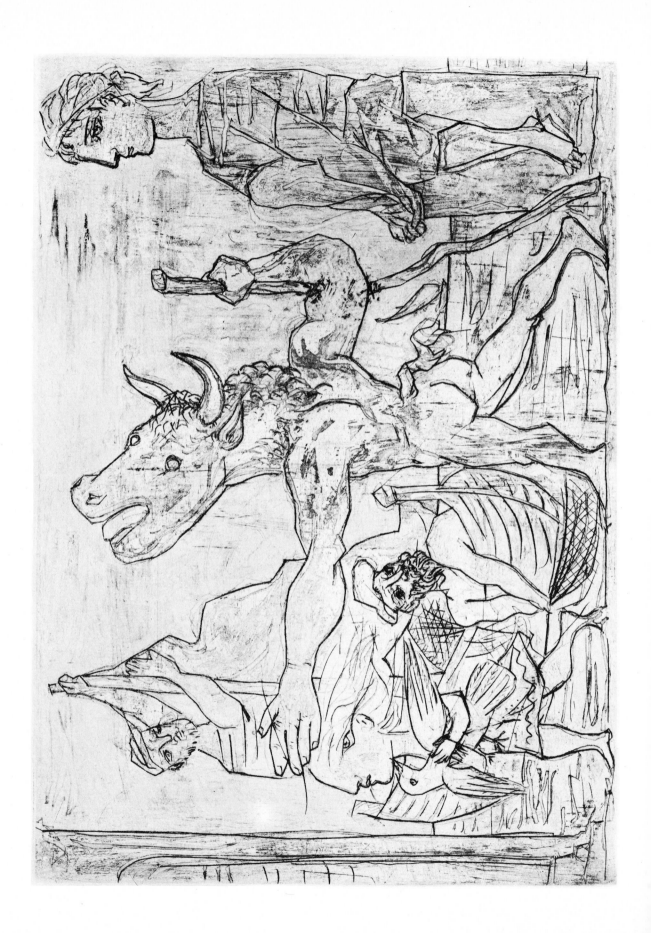

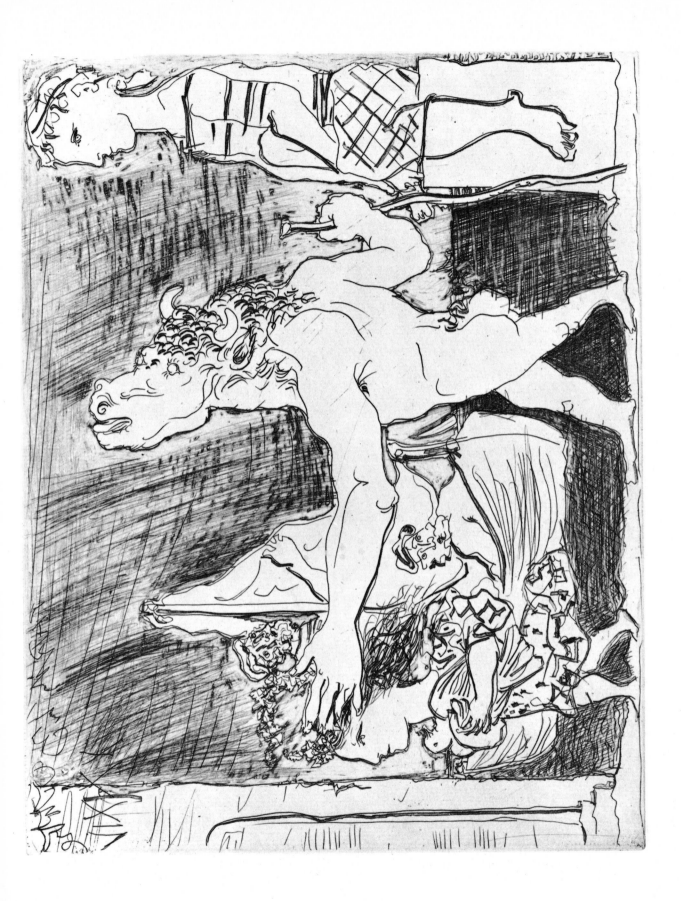

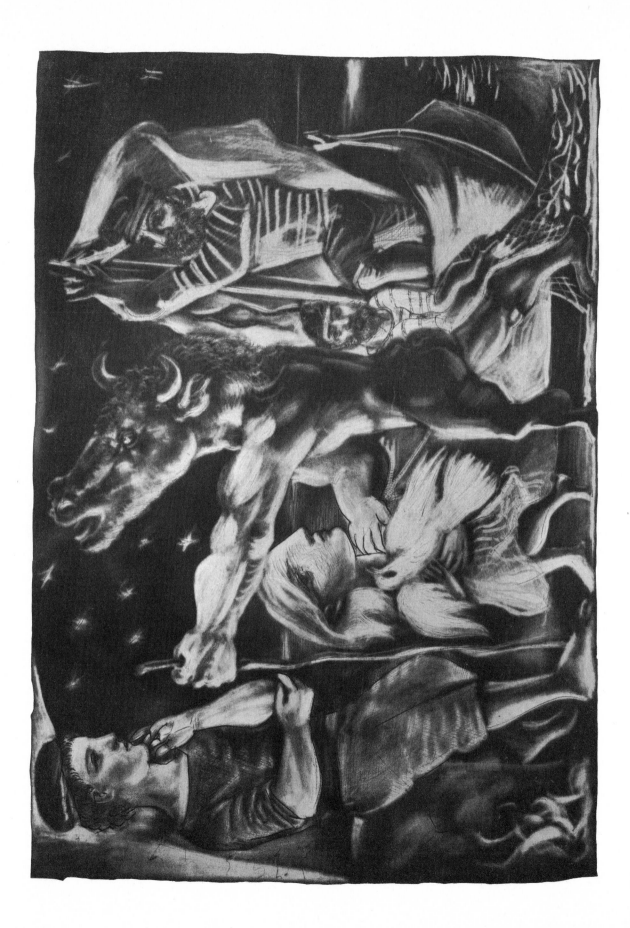

PORTRAITS OF VOLLARD

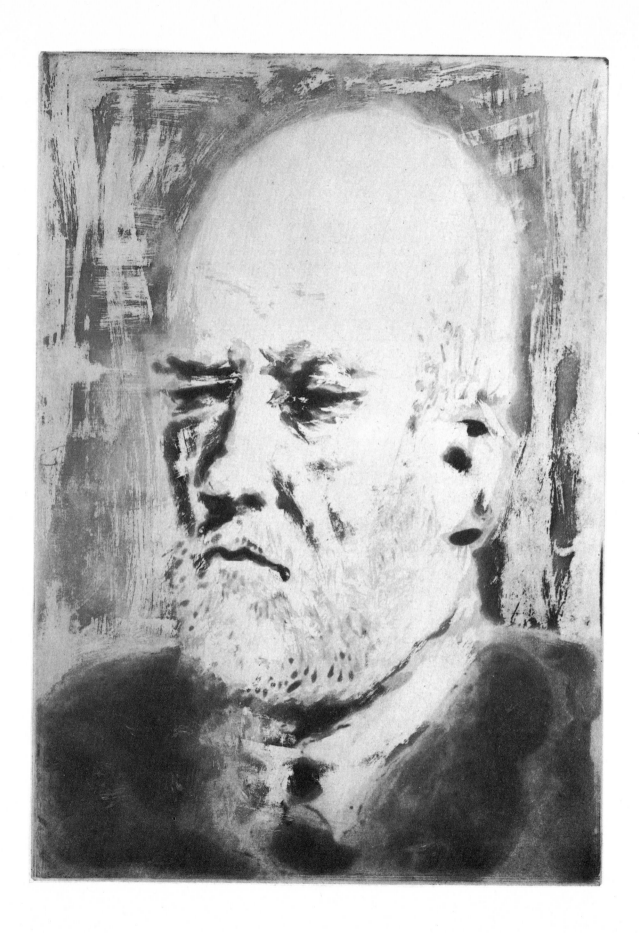

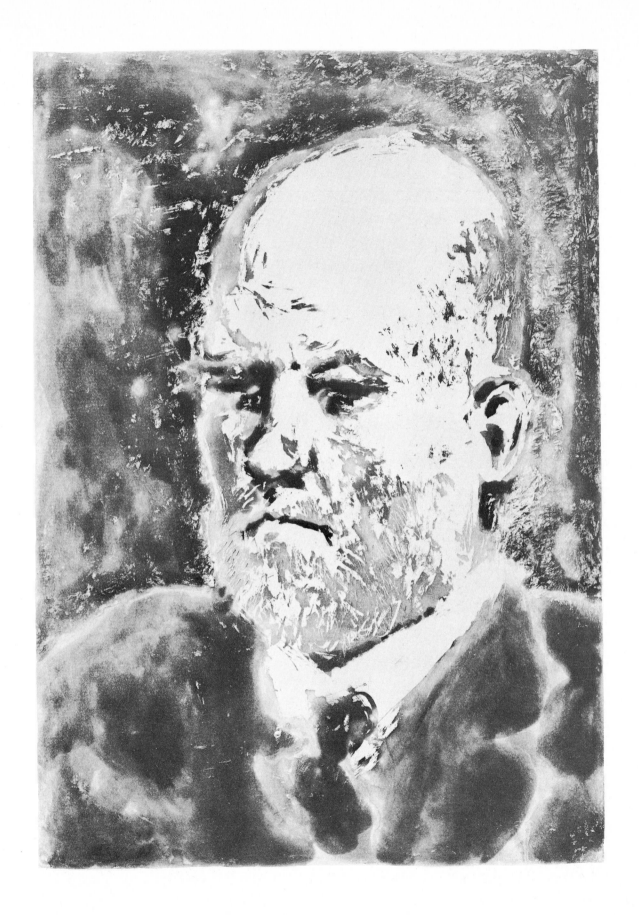